IMAGES
of America

BRIDGEHAMPTON

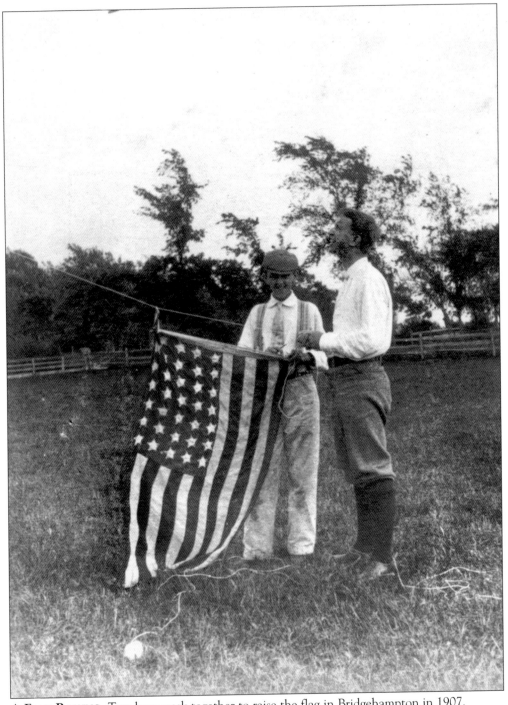

A FLAG RAISING. Two boys work together to raise the flag in Bridgehampton in 1907.

On the cover: **ON DISPLAY, C. 1915–1920.** Rink Bassington and Courtney J. Rogers (1890–1977) enjoy the crowd gathered around their vehicle at the Bridgehampton Road Races.

IMAGES
of America

BRIDGEHAMPTON

Geoffrey K. Fleming

ARCADIA

First printed in 2003.

Published by Arcadia Publishing,
an imprint of Tempus Publishing Inc.
2A Cumberland Street
Charleston, SC 29401

Printed in Great Britain.

Library of Congress Catalog Card Number: 2003103785

For all general information, contact Arcadia Publishing:
Telephone 843-853-2070
Fax 843-853-0044
E-mail sales@arcadiapublishing.com

For customer service and orders:
Toll-free 1-888-313-2665

Visit us on the Internet at www.arcadiapublishing.com.

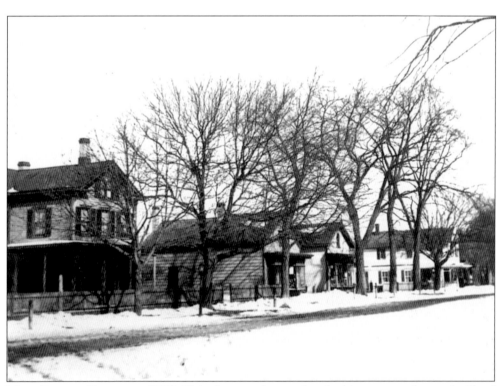

MAIN STREET, FEBRUARY 1907. This photograph was taken looking east on the north side of Main Street. From left to right are the residence of Gilbert F. Hallock, the store of Gilbert F. Hallock, the first store of Edwin Jones Hildreth, and the W.H. Rogers Pharmacy.

CONTENTS

ACKNOWLEDGMENTS

The majority of the images in this book come from the archives of the Bridge Hampton Historical Society. It is only through the generous donation of images and historical records to that institution that a book like this has been made possible. Other images and information were provided by a host of individuals. Those who loaned materials and images or helped with the research include the following: Hester Carter, Carol Crowley, Ruth Elliston, Donald Grodski, Victor Guyer, Cathy Hand, Richard Hendrickson, Pingree Louchheim, Marjorie Ludlow, Jack Musnicki, Pastor T.J. Parlette of the Bridgehampton Presbyterian Church, Jacqueline Rea, Ann Sandford, Blanche Worth Siegfried, Gail Tiska, John White Sr., and Flo Williams. Many thanks to all of you.

A special thanks goes out to Meriwether Schmid and Larry McCarthy. Where would Bridgehampton's photographic archive be without her tireless search for images and his ability to copy them pristinely?

For those of you reading this book, should you have or know someone who has images relating to Bridgehampton, please consider sharing them with the Bridge Hampton Historical Society, P.O. Box 977, Bridgehampton, NY 11932. Thank you.

INTRODUCTION

Bridgehampton, a hamlet within the town of Southampton on the east end of Long Island, derives its origin from the 1654 land divisions of the areas along the Atlantic shore known as Mecox and Sagaponack. Josiah Stanborough built the hamlet's first homestead on one of the lots at Sagaponack in 1656. By 1670, other English settlers, such as the Howells and the Toppings, had joined the Native American population of Shinnecocks and Montauketts in harvesting the resources of the land, the sea, the ponds, and the forests. Like the Native Americans, the settlers raised crops, fished, and slaughtered beached whales. In addition, they lumbered, established trades from miller to wheelwright, and engaged a minister in 1695. The name "Bridge Hampton" first appears in the town records in 1699 and describes the linking of the growing settlements in Mecox and Sagaponack by a bridge over Sagg Pond. It was built by Ezekiel Sandford in 1686 and paid for by the town. The hamlet grew steadily during the 18th century. In 1800, the federal census counted about 1,250 residents, including 52 free African Americans and 42 enslaved people. By then, Bridgehampton had expanded beyond Mecox and Sagaponack, to Hay Ground, Scuttle Hole, Huntington Hills, and Bull Head, today's Main Street. The area covered nearly 25 square miles, and the hamlet boasted at least one meetinghouse, a library, four schools, a tavern, stores, and a post office.

Following the disruptions of the American Revolutionary War (1776–1783) and the War of 1812, young single men, and some families, began to seek land and other riches in the west. As a result of this migration and a declining birth rate, Bridgehampton's population fell during the 19th century. The immigration of Irish and Polish families that began in the 1880s could not compensate for this loss. The 1900 federal census records only 1,050 residents, 200 fewer than in 1800. Rapid expansion of the year-round population resumed only in the 1970s, after the Long Island Expressway extended to Riverhead and vacationers were encouraged to buy second homes, creating many new jobs in the region. Clearly, waves of settlers have continued to characterize Bridgehampton's history from its beginnings to the present, with families proud to cite their African, European, and Central American origins. Newcomers in every period brought their own senses of place and integrated their values, not always without discord, into the community. This process has created a diversity rarely apparent to the casual visitor.

The arrival of the railroad from New York City in 1870 ushered in a period of social and economic transformation in this community, as people, especially those from the city, filled the 36 boarding houses advertised in an 1877 railroad brochure. Year-round families benefited from the new source of income, and eventually, some of the summer residents dotted the landscape with cottages of their own. By the outbreak of World War I, in 1914, the hamlet's citizens had already welcomed the use of engines on the farm, steam locomotives and automobiles for travel and commerce, electricity, the telegraph, and the telephone.

Of course, recording this panoply of people and technology was the camera. Aspects of this "modern" Bridgehampton, unlike the hamlet's history from the Colonial period (1656–1776) to the Civil War (1861–1865), were captured magnificently by studio and itinerant photographers and, eventually, by just about everyone. The large photographic archive at the Bridge Hampton Historical Society is the major source for the series of well-researched portraits and snapshots selected here for presentation by Geoffrey Fleming, who until recently served as the society's director. The earliest photograph dates from c. 1845 and the most recent from 1990. In the main, however, this pictorial history captures people and their environment as they worked, worshiped, studied, socialized, and played here during roughly the first 50 years of the 20th century. We see buildings, machines, automobiles, and activities that primarily involve members of the middle classes. While photographs rarely convey the everyday experiences of child rearing or work on the farm, the expressions of pride, joy, and occasionally boredom captured on the faces in this book make its narrative a realistic portrayal of the past. It enhances our understanding of the hamlet's history and is a welcome asset as we look forward to celebrating Bridgehampton's 350th anniversary in 2006.

—Ann H. Sandford
Trustee, Bridge Hampton Historical Society

One

FARMS AND MILLS

From the earliest times, Bridgehampton was an agricultural community. Common crops included corn, rye, and occasionally wheat. Flax was an important commodity and was heavily used in Bridgehampton's weaving industry. By the time the port of Sag Harbor opened and until the latter part of the 19th century, most farmers in Bridgehampton raised cattle. The cattle would be run out to Montauk each summer and brought back to the hamlet for the winter. As German, Irish, and, later, Polish immigrants settled in Bridgehampton, the potato became king, and by 1900, it was the dominant crop being raised in the hamlet. Today, potatoes still play an important role in local agriculture, but they have been steadily losing ground to the grape and to development. Of the windmills that once surrounded Bridgehampton, all but two are gone, and only one of these two surviving mills still stands in the hamlet, the Beebe Mill. These windmills, all of English design, ground corn into flour for men and grain for animals. They had winds strong enough to run 180 days a year on average.

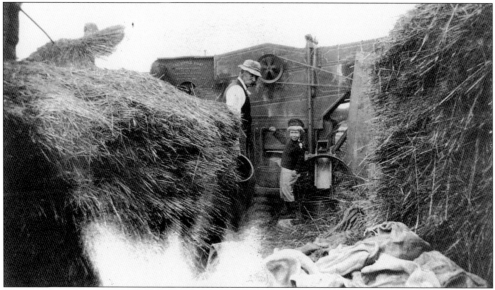

THEODORE HAINES WITH HIS GRANDSON JOHN THOMPSON JR. (1906–1994), C. 1910. The giant threshing machine behind them was typical for the period. It marked the beginning of the introduction of advanced machinery into the traditionally labor-intensive farming industry that surrounded Bridgehampton.

ON THE GUYER FARM, C. 1920. Victor Guyer (1853–1923) immigrated to America from Austria in 1884 and arrived in Bridgehampton and began farming in 1895. The Guyer family first farmed the land that is now the Atlantic Golf Club, on Scuttlehole Road. Old barns and horse-drawn wagons, although a little shaky and outdated, were still shown in use on the Guyer Farm when this picture was taken.

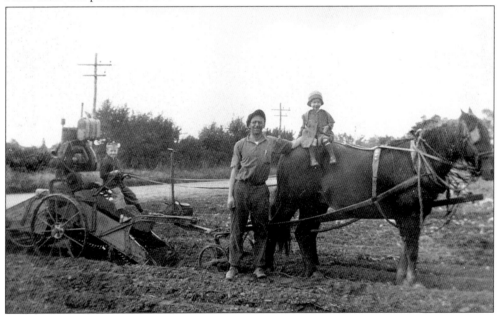

THE YOUNG FARM, C. 1925. Raymond Alonzo Young (1894–1945) purchased a farm on the north side of Scuttlehole Road in 1922, along with a commodious farmhouse called the Maples. He is shown out in the fields on his farm, with two of his children, Dudley Young and Carol Young.

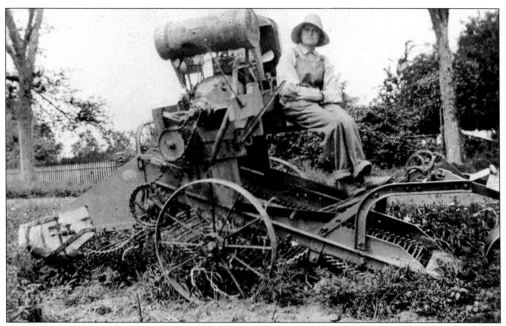

ON THE MUSNICKI FARM, 1926. Bertha Musnicki (1906–1980) rides atop a horse-drawn Shaker-type digger on the family farm on Hedges Lane. Anthony Musnicki (1879–1959) and his wife, Eva (b. 1878) arrived in America in 1904 and came to Bridgehampton to participate in the booming agricultural business.

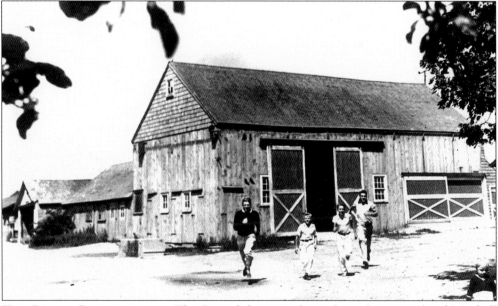

THE RUPPEL BARN, C. 1927. The Ruppel farm was located on the east side of Mitchell Lane in Bridgehampton. The large barn shown in this image was built for John Ruppel in 1904 by local funeral director C. Hampton Aldrich (1852–1912). It was destroyed by fire in the mid-1900s. Pictured running from the barn are Robert Ruppel, Valentine "Buss" Ruppel, George Ruppel, Frank Ruppel, and Edward "Winslow" Ruppel. The Ruppel farmhouse still stands in its original location.

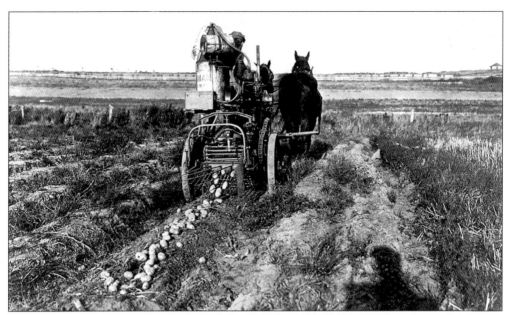

HARVESTING POTATOES, THE 1930S. John C. White Sr. (1881–1946) is shown harvesting potatoes with a horse-drawn one-row Shaker-type digger, powered by a Cushman engine. Looking east toward Gibson Lane, this view shows the White home lot. The White family, one of the oldest in the area, is directly descended from Rev. Ebenezer White (1672–1756), the first minister of the Church of Christ in Bridgehampton, who served from 1695 to 1748.

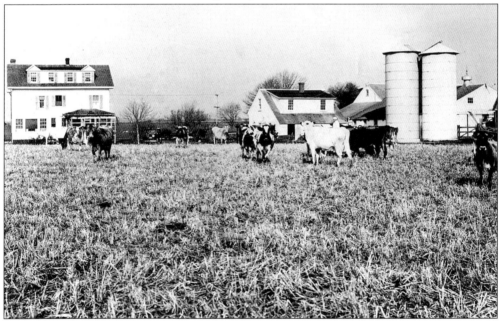

THE LUDLOW FAMILY DAIRY, THE 1930S. Started by Henry "Harry" Sylvanus Ludlow (1886–1936), the dairy was later managed by his son, Gurden (1919–2001). In the background is the Ludlow homestead, located on the west side of Mecox Road just south of Horsemill Lane. It was Harry Ludlow who aptly venerated Bridgehampton as "the Paradise of the World." The Ludlow family continues to farm this land to the present day.

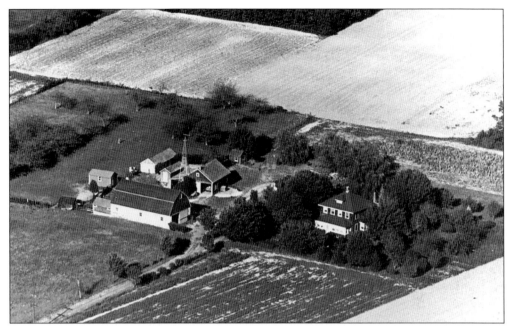

THE KOMINSKI FARM, 1932. The Kominskis were one of dozens of Polish families who settled in and around Bridgehampton and took up farming. Their farm was located on the east side of Sagg Road opposite the intersection of Narrow Lane. The farm is shown after the construction of its new barn, which was built between 1926 and 1932.

THE STRONG FARM, 1940. The Strong family has occupied this site since the time of James Strong (1796–1866). In this aerial view, most of the buildings can be seen, including the main house, the large 18th-century barn, the pigpen, the corncrib, the fertilizer house, and the migrant house. The Old Paint Shop and Strong Wheelwright Shop (lower left), constructed *c.* 1875, was moved to the grounds of the Bridge Hampton Historical Society in 1962.

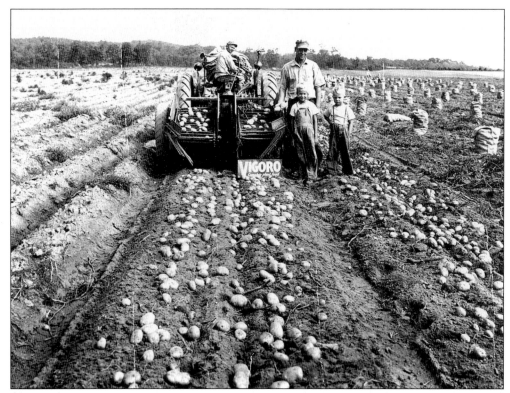

ON THE TISKA FARM, 1944. This photograph was taken so that it could be used in an advertising campaign for the Vigoro Plant Food Company. The Tiska Farm was located on the east side of Millstone Road, and at the time it was purchased in the 1930s, it comprised nearly 223 acres of woodland, orchards, and fields planted in corn, potatoes, oats, wheat, and hay. Shown in one of the potato fields are "Gump" Tiska and his brother Anthony Tiska, with Anthony's children "Spunky" and "Tony."

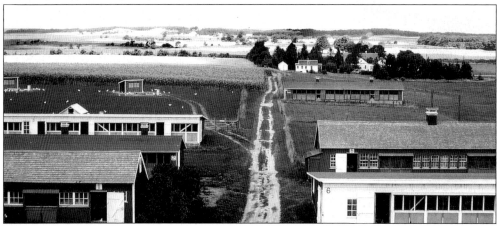

HILL VIEW FARM, 1954. Hill View Farm was operated by Howard Hendrickson (1889–1984) and his son Richard (b. 1912). Howard Hendrickson purchased the farm from Mrs. Nathan N. Tiffany in 1906. The farm was known for its herd of Guernsey cows, as well as for being one of the largest producers of chickens on eastern Long Island. The farm was located on Lumber Lane. In this 1954 image, the chicken houses (and the chickens) are clearly visible.

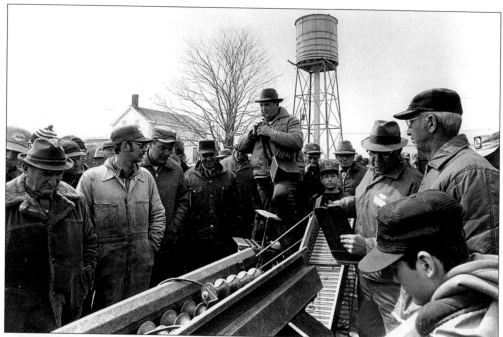

A FARM AUCTION, 1967. The contents of the McNamara Farm go up for auction. The auctioneer (center) stands above the onlookers, who are preparing to bid on some machinery. The farm was located on the west side of Butter Lane just south of the present Hampton Day School complex. Local farmers and the curious showed up to bid on all sorts of farm equipment and general goods.

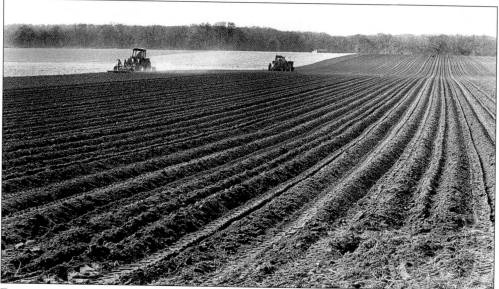

FARMING ON SAGG MAIN, THE 1980s. Clifford Foster farms the land on the west side of Sagg Main Street behind the Sagg School, with Sagg Swamp beyond. Foster is one of the most successful farmers on the South Fork, working both his and leased lands all over Bridgehampton. The Foster family settled in Southampton township in 1651, and the family farm is on Sagg Main Street.

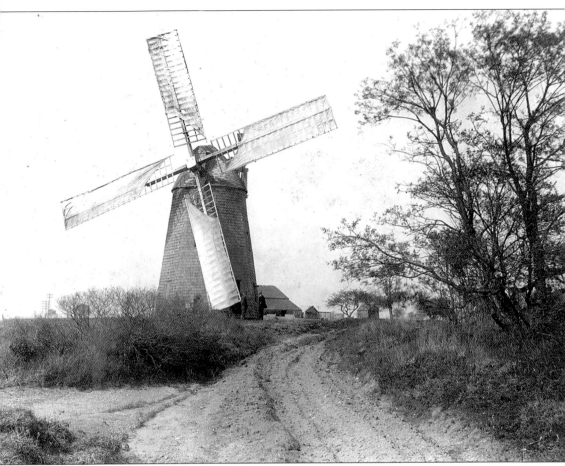

THE HAYGROUND WINDMILL, C. 1890. Constructed in 1801 on a hill overlooking Hayground Road near the intersection with Montauk Highway, the Hayground Windmill was first operated in 1802. The mill was owned by a partnership consisting of Gen. Abraham Rose (1765–1843), Benjamin Rogers (1769–1842), Nathan Topping Rogers, and Ethan Topping (1751–1829). Several millers were in charge of the mill during its operative years, including Ethan Topping, Jesse Topping, George Topping, George Topping II, and Maltby G. Rose. During the 1920s and 1930s, it served as an artist's studio for the noted painter Agnes Pelton (1881–1961), as well as an antiques shop. The mill was purchased in 1950 by Robert Dowling and moved from Hayground to East Hampton to be a part of his private estate. In this image the blades of the mill are covered with their sails.

AT THE HAYGROUND MILL, C. 1900. From left to right are Madison Topping, miller Maltby G. Rose, and neighbor Orlando Rogers.

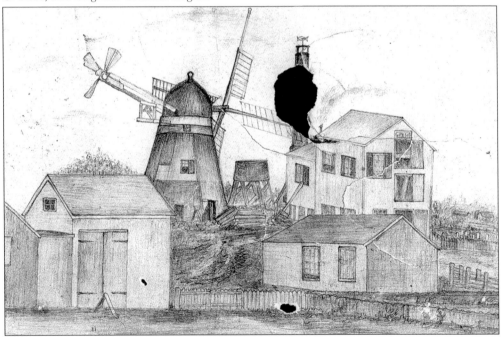

A DRAWING OF MILL HILL. Mill Hill was located on the west side of Ocean Road between Hull Lane and the present Presbyterian Manse. This drawing depicts the Beebe Windmill after it was moved from Sag Harbor to Bridgehampton. This was done in 1837, after Judge Abraham T. Rose and Richard Gelston purchased the mill and moved it to the village. On the right is the Atlantic Flouring Mills, built by Maj. Roger A. Francis in 1851. To the right of this mill, the gravestones in the Old Cemetery can be seen.

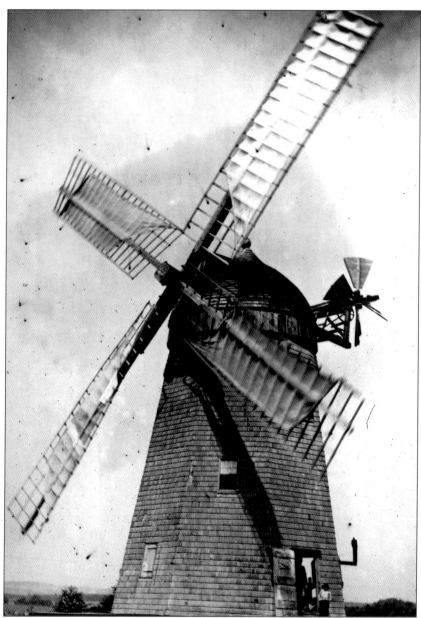

THE BEEBE WINDMILL, C. 1900. This windmill was first erected in Sag Harbor on Sherrill Hill in 1820. It was the first mill on Long Island to have a "fantail." It was built for Capt. Lester Beebe, who operated it until 1837, when it was sold to Judge Abraham T. Rose and Richard Gelston and moved to Bridgehampton to Mill Hill. In 1882, it was sold to J.A. Sandford, who moved the mill to a site located north of the railroad tracks. There, Sandford installed a steam engine to enable the mill to operate even if the wind was not strong enough. Rev. Robert Davis purchased the mill c. 1914, when he was approached by John E. Berwind, who bought it from him and moved it to the gardens at Minden, his estate on Ocean Road. There it sat until May 1935, when Berwind's wife moved it to the former Hallock property located north of Minden. Not long afterward, the mill and land were presented to the town of Southampton in memory of the late John E. Berwind.

Two

BUSINESSES

Commerce has always been important in Bridgehampton. At first, the selling and trading of land and property was primary, but by the late 18th century, other industries had taken hold. Weaving, whaling, importing, carting, and the transportation industry all flourished. From the 1830s to the 1860s, almost everyone in Bridgehampton earned a living in some manner from the whaling industry. If you did not go on a voyage yourself, you held shares in the wharf or your company helped to supply ships in port. As the whaling industry began to fade, a new one invigorated Bridgehampton: the railroad. After the railroad arrived, the hamlet began to establish Main Street stores that would provide goods and services brought by train to the public. Hildreth & Hand, Loper's Store, D.L. Chester's Dry Goods, as well as hotels and inns like Hampton House and the Atlantic House, led the way to prosperity. By the 1920s and into the 1950s, these businesses were replaced by those founded by the immigrant families who had begun to arrive in Bridgehampton in the 1880s. Schenk Meats, Basso's Restaurant, Sivigny's Drugstore, Rana's Variety Store, and others similar stores brought business in Bridgehampton into the modern era.

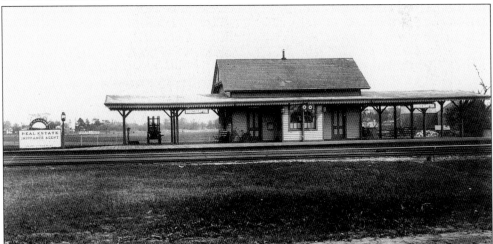

THE SECOND BRIDGEHAMPTON STATION, C. 1905. The first station, constructed in 1870 when the railroad arrived, burned in 1884 and was rebuilt. The second one was an attractive Victorian building with wide, covered verandas. Visible are an advertising sign for Humblet's Real Estate Agency (left) with the outline of the William Corwith beyond. The station fell into decline following World War II and was demolished in 1964.

THE BULL'S HEAD TAVERN (JOHN WICK HOUSE), C. 1910. This was one of the original buildings that formed the first phase of the movement of the Bridgehampton settlement up from around Sag Pond and on to the King's Highway. Constructed *c.* 1685 in the saltbox architectural style, the house was altered in the 18th century to resemble the popular designs of the Georgian period. By 1695, John Wick had purchased the house and begun its use as a tavern. Called the Bull's Head Tavern, it featured a sign with the image of a bull's head that hung out front. This name eventually became associated with the village itself. In the late 1930s, the house came up for sale, and local citizens tried to raise money to buy the building to preserve it. This appears to have come to no avail, and in February 1941, the Bull's Head Tavern, over 250 years old, was demolished to make way for a gasoline station. In this image, the house is apparently all decked out for the 250th anniversary celebration in 1910.

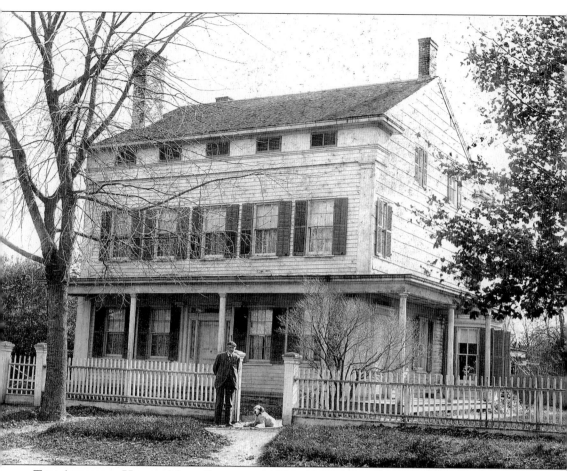

THE ATLANTIC HOUSE, MAIN STREET, C. 1890–1900. Located originally on the corner of Montauk Highway and the Sag Harbor Turnpike, the Atlantic House was moved to the present site of St. Ann's Church on Main Street in 1835. There, it was raised up, and another story was built under it. It opened as a tavern called the Atlantic House. The business was sold in 1865 to John Hull, during whose long tenure it became known as one of the best hotels and eateries on Long Island. Hull's selection of foods, and particularly his game suppers, became known as far as New York City. Beside feeding and housing visitors, the building served as a dance hall on occasion as well. Hull died in 1902, ending 37 years of operation under the careful eye of its owner. No one seemed able to keep the business up, and by 1908, the whole property was sold to the Episcopal Church. In 1914, the building was removed to make way for the present parish house.

THE TOLLHOUSE, SAG HARBOR TURNPIKE, C. 1900. The Bull Head Turnpike Company was established in 1840 and operated what we know today as the Sag Harbor Turnpike as a private toll road. The Turnpike Company was a profitable venture, until the railroad was extended from Bridgehampton to Sag Harbor in 1881. The road fell into disrepair as traffic slowed considerably, and for many years the road became worse and worse. In 1906, the town took control and the road was repaired and the tollgates were removed. The tollhouse on the Sag Harbor Turnpike burned to the ground in 1909, removing the last vestige of the old toll road system from Long Island.

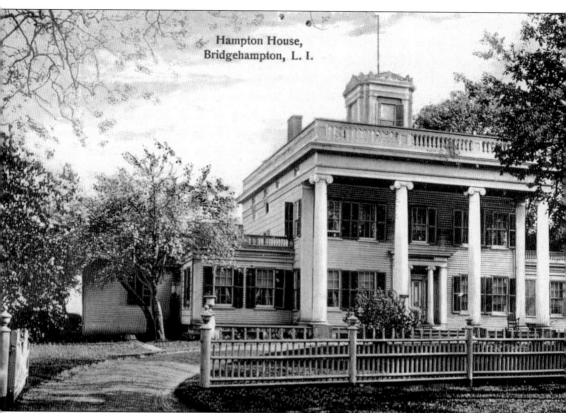

Hampton House,
Bridgehampton, L. I.

HAMPTON HOUSE (NATHANIEL ROGERS HOUSE). The building known as Hampton House was constructed *c.* 1842 for Nathaniel Rogers (1787–1844). Rogers was initially involved as a draftsman in the ship-building industry in New York City, although, later, because of a knee injury, he returned to Bridgehampton. Soon after his arrival in Bridgehampton, he began to study painting, and in 1811 he returned to the city to study with Joseph Wood (1778–1830). Rogers eventually became one of the foremost miniature painters in New York City during the early 19th century. He suffered an attack of tuberculosis in 1825, and from that point forward, remained on Long Island most of the time, although he maintained his New York City studio until 1839, when he retired to Bridgehampton permanently. After his return, he purchased a site in the village belonging to the Rose family and began construction of a new residence, which is best remembered as Hampton House—a first-class hotel and boardinghouse, run by the Hedges and Hopping families and famous for its lavish hospitality.

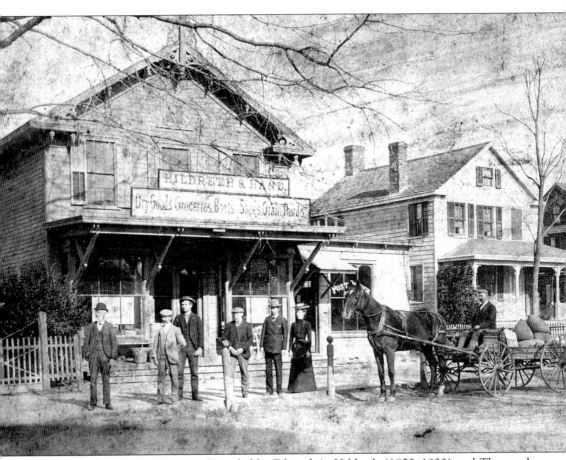

HILDRETH & HAND, C. 1907. Founded by Edward A. Hildreth (1852–1923) and Thomas J. Hand (1860–1911), this Main Street icon was opened c. 1885. A true general store, the shop carried, among other things, "groceries, hardware, crockery, shoes, paints, seeds, and general merchandise." The building had telephones available for its customers to use and delivery wagons to bring merchandise to their front doors. From 1897 to c. 1920, the building housed the Bridgehampton Post Office in the small addition on the right where, conveniently, Hildreth was postmaster. Following Hand's death in 1911, Hildreth continued the business on his own. The store probably closed following Hildreth's death in 1923. The building later served a number of businesses, including Rana's Variety Store from the 1950s to 1973. Rana's Variety Store was founded by Pat Rana (1915–1999) and Maureen G. Rana (1922–1997). Today, the building houses the Town Deli and Dayton Halstead Real Estate. To the right of the store is the home of Hannah Hand (1863–1928) and Clara Downs (1858–1923), and beyond is the residence of Gilbert F. Hallock (1854–1905).

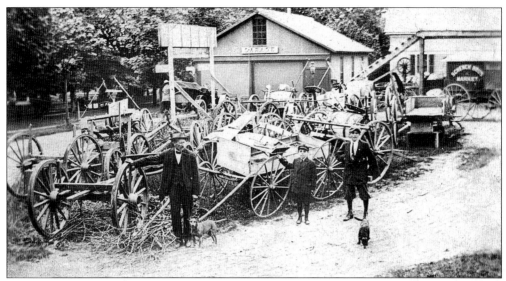

HALSEY & MCCASLIN, C. 1910. In 1886, Francis McCaslin (1857–1937) joined with Howard S. Halsey (b. 1855) to form a new business on Mill Hill: Halsey & McCaslin, located on the west side of Ocean Road. McCaslin and Halsey repaired carriages and automobiles (the automobile garage was constructed in 1908) and remained in business until 1921, when the site was cleared for the present Talcott Park. Visiting the shop are Bill Schneider and his brother and dogs (right foreground). The Schenk Brothers Market wagon (right background) is probably in for repairs.

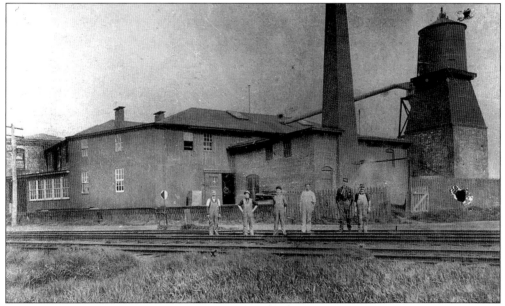

EAST HAMPTON LUMBER AND COAL MILL, RAILROAD AVENUE, C. 1900. Founded by J.E. Huntting of East Hampton and incorporated in 1889, the East Hampton Lumber and Coal Mill, was located on Railroad (Maple) Avenue, a location chosen because the train lines did not connect to East Hampton. The company carried a number of items, including millwork, sashes, dressed lumber, brick, cement, and coal. Today, only the small brick building at the right (currently the Battle Iron and Bronze Shop) remains.

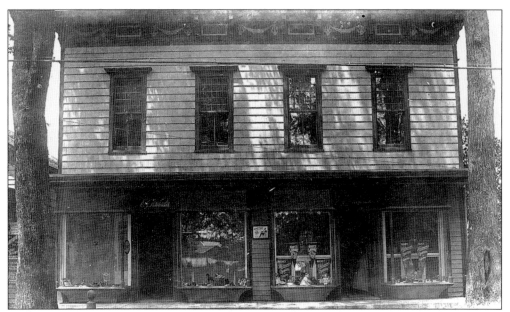

E.J. HILDRETH'S STORE, MAIN STREET, C. 1912. The store, built c. 1888, was owned by Edwin Jones Hildreth (1865–1938). It sold "sporting goods of all kinds, as well as stationery, confectionery, souvenir post cards and novelties." In the rear of the shop, Hildreth and his staff, serving as agents for the Majestic Bicycle Company, repaired bicycles. The original small structure was enlarged c. 1912 to appear as shown here. The store was closed in 1925, and the contents were auctioned off.

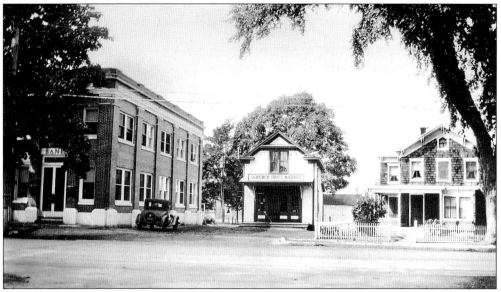

THE SCHENK BROTHERS MARKET AND HOUSE, 1932. The Schenk Brothers Meat Store (center) was located on Main Street in a small building just east of Loper's Store. In 1910, Frank Schenk (1887–1968) and Conrad Schenk (1859–1941) worked there as butchers. The building was enlarged in 1932, the year it became a Royal Scarlet Store. The store is no longer standing, but the Schenk house (right) was purchased in 1970 by William G. Thompson and moved to New Light Lane in Hayground.

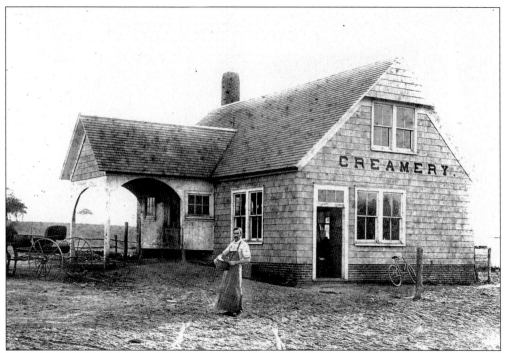

THE BRIDGEHAMPTON CREAMERY COMPANY. This company was organized in 1898, and nearly every farmer in town had stock in it. It was located where the Esp Fuel Company complex sits today. The creamery processed milk and produced cream and butter. By 1907, the business had processed more than seven million pounds of milk. The creamery went out of business some time between 1910 and 1920. Shown is the original creamery building, possibly with E.J. Thompson, the creamery manager, standing in front.

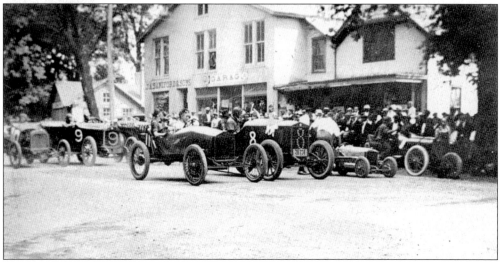

JAMES A. SANDFORD & SONS SHOP, C. 1920. James A. Sandford began his plumbing and heating business in 1894 and, in 1901, entered the piped gas business. In 1906, Sandford began constructing a public water system that fulfilled Bridgehampton's water needs for many decades. Located on Main Street, his shop is shown at race time, with its original west wing, now long gone. The business was sold in the 1980s.

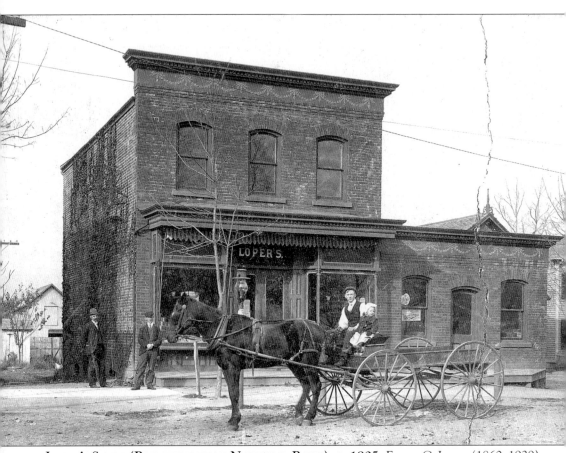

LOPER'S STORE (BRIDGEHAMPTON NATIONAL BANK), C. 1905. Ernest C. Loper (1860–1929) ran several successful business, including the Sagg General Store, before he a started his grocery business in this brick store, built *c.* 1903 on Main Street. He carried a myriad of items, including "staple and fancy groceries, canned goods and table luxuries, fruits, vegetables, berries, and pure food supplies generally, as well as general merchandise." In 1910, the newly formed Bridgehampton National Bank began leasing the east wing of the building, and in 1920, it purchased the entire building. The bank enlarged the east side of the building for its offices, and the post office took over the west side. By 1925, the bank wanted a more improved look for the structure; thus, in 1926, the entire building was wrapped in face brick and the east side was raised to two stories. The bank occupied the renovated building until the construction of its new headquarters on the corner of Snake Hollow Road and Montauk Highway. This building still exists today and is partially occupied by Starbucks Coffee.

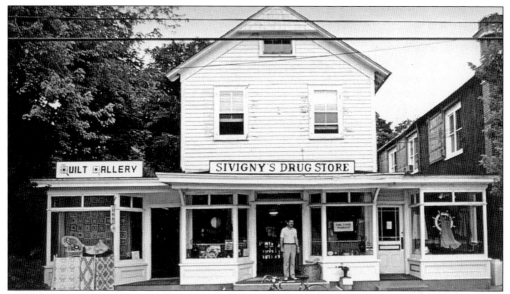

SIVIGNY'S DRUGSTORE, MAIN STREET, C. 1970. Sivigny's Drugstore was located on Main Street, next door to Ernest C. Loper's grocery store. It was originally built as W.H. Rogers Pharmacy and replaced Babcock's Pharmacy, which had burned to the ground in 1898. After W.H. Rogers ran the pharmacy, it was operated by Leroy Tiffany. The Sivignys' cousins, the Kramers, operated a pharmacy in the hamlet of Southold on the North Fork. Today, a barber shop and clothing store occupy the building.

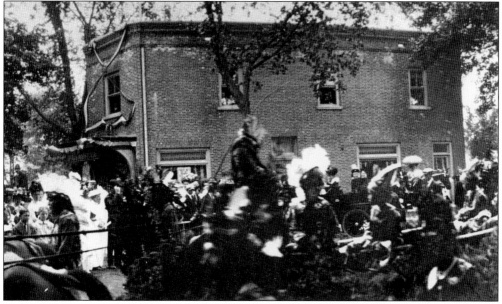

THE D.L. CHESTER DRY GOODS STORE. Daniel L. Chester (1862–1926) opened his first store c. 1900. On December 22, 1906, the store burned, and his stock was destroyed. Chester decided to build a new store down the road, and when it opened in 1907, the D.L. Chester Dry Goods Store, shown here, was one of the most modern (and fireproof) establishments in Bridgehampton. After 1926, the building had several occupants, including Muller's White Rose Market, beginning in 1947. In recent times it has housed a number of restaurants.

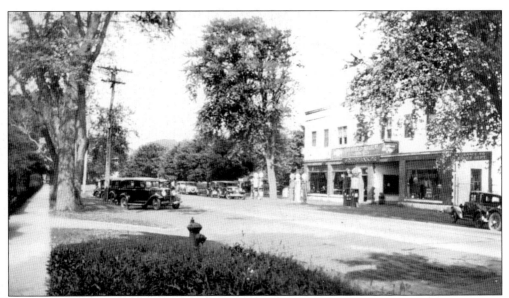

THE STUDEBAKER DEALERSHIP, JUNE 1931. Located on Main Street, the Studebaker dealership has placed a number of automobiles on display along both sides of the road. Even a small hamlet like Bridgehampton had an automobile dealership of its own at one time. Today, the building is the home of Pulver Gas, although the Studebaker emblem can still be seen at the very top of the building.

THE BRIDGEHAMPTON CANDY KITCHEN, C. 1976. Opened to rave reviews in 1925, the Bridgehampton Candy Kitchen quickly became a gathering place for everyone from farmers to movie stars. Run by the Stavropoulos family for many years, it is operated today by Gus and Vivi Laggis.

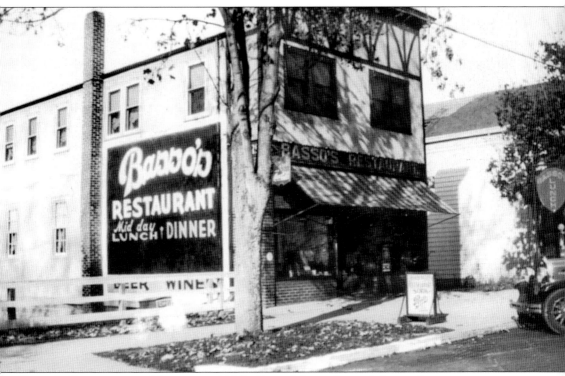

BASSO'S RESTAURANT, NOVEMBER 1935. One of the earliest of the modern restaurants in Bridgehampton, Basso's was owned by Frank and Celestina Basso. Originally only one story tall, the building was expanded to two stories as its popularity grew. It is shown when it still had its painted billboard advertising sign on the building's west side. This building later became the famous Bobby Van's. Bobby Van's was a Hamptons staple in the 1950s and 1960s. People from all over would come to hear Bobby Van play his signature tunes on the piano. In the 1980s, Bobby Van's made the move from the north side to the south side of Main Street. Today, the World Pie restaurant occupies the building.

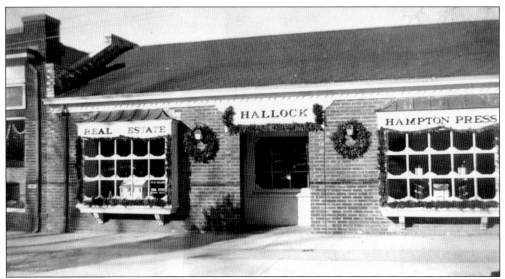

THE HAMPTON PRESS, 1947. The Hampton Press began in 1895 and was the publisher of the *Bridgehampton News*, the local newspaper. The Press also published greeting cards, pamphlets, and books, including the 250th anniversary program printed in 1910. The *Bridgehampton News* was purchased by the *Southampton Press* in 1965 and merged with that publication in 1968. The Hampton Press continued to operate its printing shop until the early 1990s. It is shown next to Hallock Real Estate, on the north side of Main Street.

THE SAGG GENERAL STORE, C. 1939. The Sagg General Store was constructed c. 1878 by Thaddeus S. Edwards as a general store and post office for the hamlet of Sagg. The Hildreth family, who continues to operate the store to the present day, purchased the building c. 1898. It was enlarged c. 1900 and, in 1948, was damaged by a fire. Despite these changes, it remains one of the most popular small stores in the Hamptons.

Three
PEOPLE AND PLACES

Although Bridgehampton has never been very large, it has always had a very diverse population. Native Americans, African Americans, and their European counterparts, including English, German, Irish, Swedish, and Polish people all have come to Bridgehampton to make their mark. The village can boast many important residents, including judges, senators, legislators, and especially Southampton town officials. In fact, records show that until the mid-19th century the majority of posts in town government were held by residents of the Bridgehampton area. What follows is just a brief sampling of some of the more famous, notable, and interesting citizens who have made Bridgehampton their home.

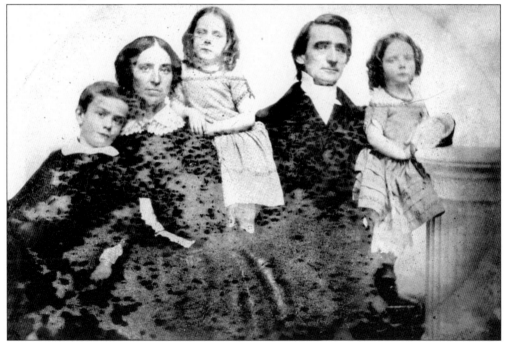

REV. AMZI FRANCIS AND FAMILY, C. 1844. Amzi Francis (1793–1845) was born in West Hartford, Connecticut, and was ordained in Bridgehampton. The third minister of the Presbyterian Church, he served from 1823 to his death in 1845. He is remembered as one of the most "industrious, devout, logical, self-denying saints" to ever preach in the hamlet. He is shown with his second wife, Mary S.H. Francis (1808–1897), and some of their children.

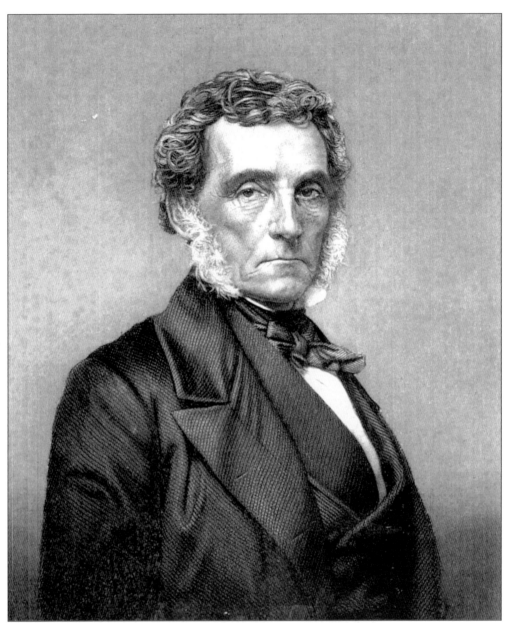

THE HONORABLE JUDGE ABRAHAM TOPPING ROSE (1792–1857). Born in Bridgehampton, Abraham Topping Rose attended the local schools, graduated from Yale in 1814, and began to study under Mr. Sandford, the district attorney for New York City. In 1823, Rose married Eliza Van Gelder, daughter of the former mayor of New York City. A successful local attorney, he was often involved in cases brought against the town. He was elected county judge and surrogate in 1840, 1844, and again in 1856. His poor health kept him from serving in other positions, and instead, he focused on other pursuits. Rose was an accomplished and discerning musician and an avid hunter, and he participated in these activities with great enthusiasm. Toward the end of his life, he was so distraught with the state of politics that he ran for office again and was reelected as county judge and surrogate. He was forced to resign his post due to ill health a month before his death on April 28, 1857.

COL. EDWIN ROSE, (1807–1864).
The son of Dr. Rufus Rose
(1775–1835), Edwin Rose was born
at Hayground. He attended West
Point Military Academy, graduating
in 1830. During the 1830s, he saw
action in the Black Hawk and
Seminole Wars and was
commissioned to survey the shores
of Lakes Michigan and Huron.
Following the resignation of his
commission in 1838, he returned to
Hayground, where he became active
in local and state politics, eventually
serving as supervisor of
Southampton township and as a
three-term representative to the
New York Sate Legislature. When
war was declared in 1861, he quickly
joined the army, becoming colonel
of the 81st New York Volunteers,
where he saw service in the
Peninsular Campaign. In 1862, in
failing health, Rose was forced to
give up his field position in
the 81st. He returned to Long
Island, where he was made provost
marshal, a position he held until his
death, in Jamaica, Queens, on
January 12, 1864.

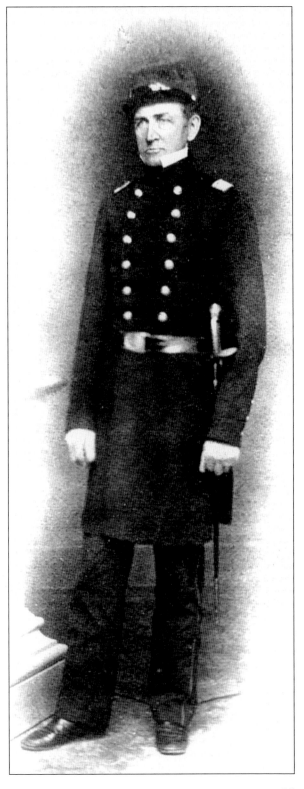

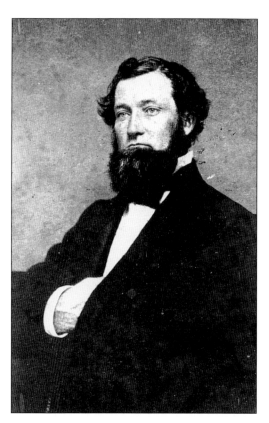

CAPT. HENRY E. HUNTTING (1828–1903). Henry E. Huntting was trained as a cooper and went to sea to practice his craft. He joined his brother, James R. Huntting, as mate on the ship *Jefferson*, and he was soon in command of his own vessel, the *Charles Carroll*. In 1863, he was commanding the ship *Pacific* when it became badly damaged and was forced to return to Sag Harbor. In his retirement he served as overseer for the third district of the U.S. Life Saving Service and served with distinction in the New York State Legislature.

CAPT. JAMES R. HUNTTING (1825–1882). James R. Huntting first went to sea on the bark *Portland* in 1841. He commanded many ships during his career, including the *General Scott* in 1860 and the *Fanny* later in the 1860s. He helped found the local mercantile firm Tiffany & Huntting. He purchased Hampton House in 1857 from Edmund Rogers (1826–1861) and lived there until the 1870s, when he sold the property. He constructed a new home south of Hampton House, where he lived out the rest of his days.

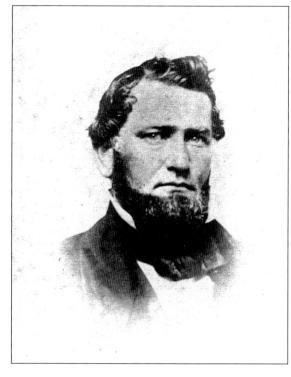

WILLIAM AUGUSTUS CORWITH (1825–1902). William Augustus Corwith was born in Bridgehampton, the son of William Corwith (1791–1872) and Hannah Halsey Corwith (1792–1860). He went to sea as a young man to participate in the burgeoning whaling industry. In 1860, he married Susan Beard (1826–1912), with whom he had five children. He inherited his father's home in Bridgehampton and, while residing there, took in summer boarders—the house could hold up to 15 guests.

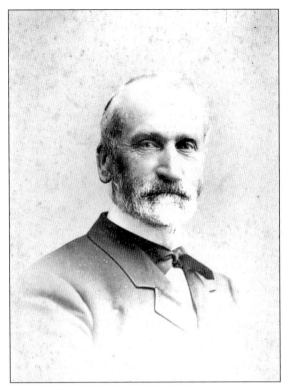

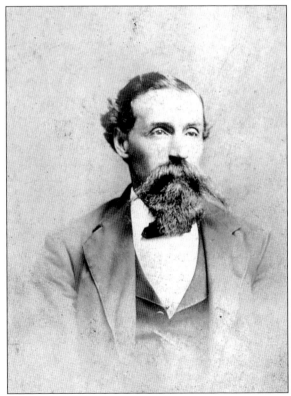

CAPT. WILLIAM HENRY SQUIRES (1837–1895). William Henry Squires was born and raised in Southold. He married Carrie Peters, who died in 1873 at the age of 31. Squires remarried and moved to Bridgehampton, to a home on Church Lane called the Pines. Squires narrowly survived a hurricane in 1887 as captain of the schooner *John R. Bergen*. He died while in command of the schooner *Louis V. Place* when it crashed off Sayville, Long Island, in February 1895.

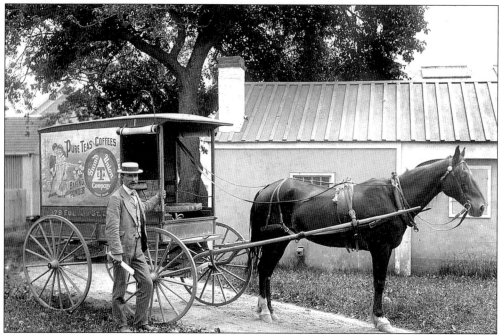

John Bradshaw and His Tea Wagon, c. 1900. John Bradshaw is remembered as a quiet man who later in life carted garbage in Noyack. He is shown here *c.* 1900 with his tea wagon, in which he traversed Bridgehampton selling his wares door to door.

Dr. Edgar B. Mulford (1848–1926). Edgar B. Mulford was born in Amagansett and trained at the Bellevue Medical College before settling in Bridgehampton in 1878. Mulford erected a house on Lumber Lane and commenced his practice, making house calls and helping to cure the ill in the community. On February 17, 1926, he was planning to head off to his afternoon appointments when he suffered a heart attack and collapsed. He died the following day and was later buried in Edgewood Cemetery.

PROF. LEWIS W. HALLOCK (1834–1909). Lewis W. Hallock was born in Brookhaven township. He started his teaching career there, later serving as a professor at Fort Edward Collegiate Institute. He served as chaplain at Middletown High School before moving to a position at Northville Academy, near Riverhead. Hallock became head of the Bridgehampton Academy in 1872 and remained there until it closed in 1907. He died in 1909 and was buried in Edgewood Cemetery, where his former students erected a large granite monument in his memory.

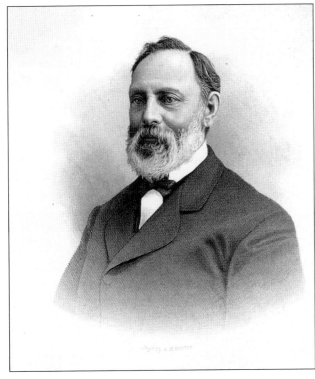

JUDGE HENRY PARSONS HEDGES (1817–1911). Henry Parsons Hedges was one of the greatest historians ever produced by Long Island, Hedges trained to be a lawyer at Yale University and set up his practice in Sag Harbor in 1843. He lived there until 1854, when he moved into his new residence in Bridgehampton, located on Ocean Road. Hedges served as a county judge, a district attorney, and a member of the New York State Assembly. He is best remembered for his history of East Hampton.

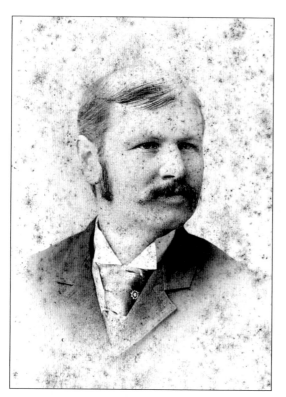

EDWARD A. HILDRETH (1852–1923). Edward A. Hildreth was born in Bridgehampton. He joined with Thomas J. Hand (1860–1911) to create Hildreth & Hand, the general store that became become an icon of Main Street. Hildreth also served as postmaster and continued to run the store after Hand's death in 1911. Hildreth was severely injured in an automobile accident on August 5, 1923, and never recovered from his injuries. He died on August 17, 1923, and was buried in Edgewood Cemetery.

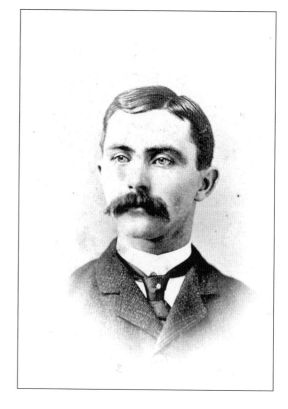

THOMAS JEFFERSON HAND (1860–1911). Thomas Jefferson Hand became the junior partner in the firm of Hildreth & Hand. He was the son of Capt. George Hand (1819–1887), the purchaser of Col. Edwin Rose's farm in Hayground. The farm was occupied by his descendants until the 1970s.

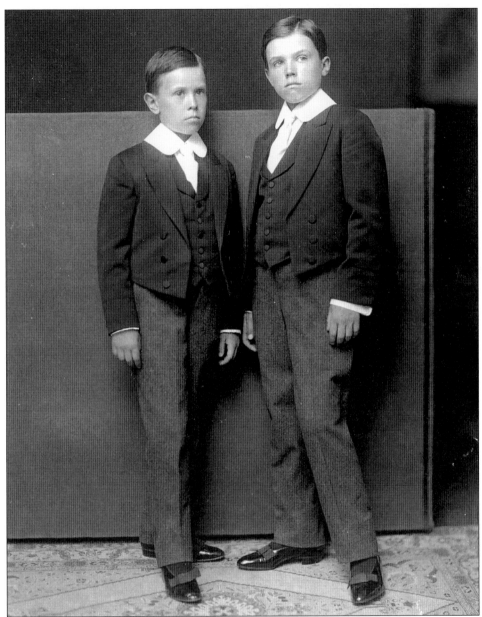

PHILIP VAN GELDER CARTER (1895–1968) AND COLIN ESTERBROOK CARTER (1894–1978). Philip Carter (left) and Colin Carter are dressed in all the finery one would expect in the Edwardian era. They were the grandchildren of Richard and Antoinette Esterbrook. Philip Carter was a great golfer and became one of the youngest players ever to qualify for the national tournament in 1908 at the age of 13. He regularly participated in the invitational tournament held at the Shinnecock Hills Golf Club in Southampton. Although many "metropolitan" golfers competed against him, only Philip Carter had the distinction of winning the tournament five times in a row. He was runner-up in the very first MGA Junior in 1912 and then went on to win in that event the next three years in a row. Both he and his older brother, Colin Carter, enlisted in Bridgehampton and served with distinction during World War I.

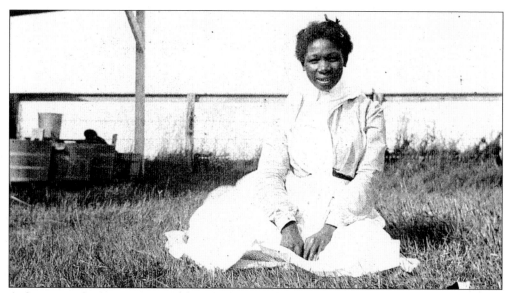

A SERVANT GIRL, C. 1906. Although there has been an African American population in Bridgehampton from the earliest times, the majority of the present families are descended not from them but from the hundreds who migrated north to escape the Jim Crow laws of the South. Many arrived as migrant farmworkers and still others as domestic servants. Their descendants make up the significant African American community of present-day Bridgehampton. Shown is a young domestic servant from Virginia on the lawn of her employers, Mr. and Mrs. Stephen B. Halsey.

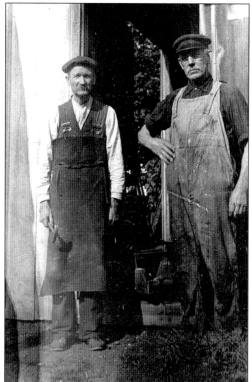

FRANCIS MCCASLIN (1857–1937) AND HOWARD HALSEY (B. 1855). Francis McCaslin (left) was born on February 1, 1857, near Belfast in County Armagh, Ireland. He arrived in the United States in 1866. In the same year, he joined with Howard S. Halsey to form a carriage repair business, Halsey & McCaslin. McCaslin was a member of the Presbyterian Church and was for many years in charge of ringing the bell before Sunday services.

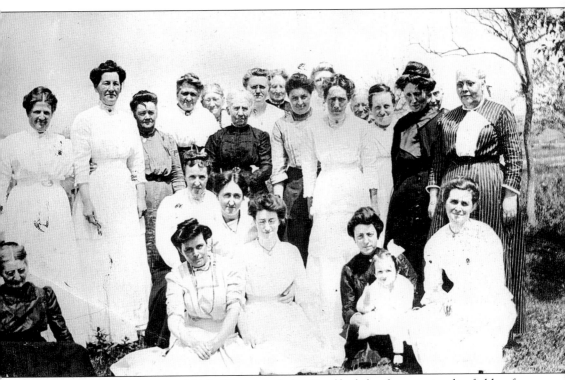

THE SANDFORD FAMILY, C. 1914. Women of the Sandford family pose in the fields of Bridgehampton. The family was one of the earliest to settle in Bridgehampton. Among those pictured are Hannah Mae Sandford, Estelle Sayre Sandford, Helen Mae Crapser, Helen Elizabeth Crapser, Florence Sandford, Alice Osborn Hand, Alena Sandford, Helen Sandford Hand, Caroline "Cad" Sandford, Sadie Winters Hand, Helen Smith Sandford, and Mary Allen Sandford.

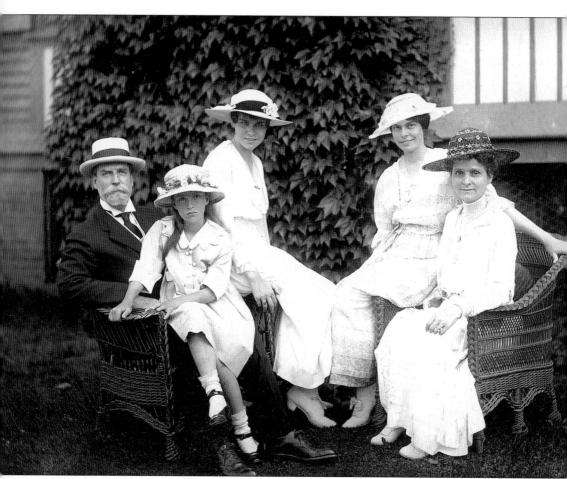

THE HUGHES FAMILY AT TREMEDDEN, C. 1916. Colin S. Carter's sister, Ellen Antoinette Carter, summered regularly in their Bridgehampton home, Tremedden, with her famous husband, Charles Evans Hughes, and their children. Hughes, a New York governor and a U.S. Supreme Court chief justice, ran for the U.S. presidency in 1916 and was supposedly in Bridgehampton the night he lost the election to Woodrow Wilson. It is said that he went to bed at Tremedden thinking that he had been elected and awoke to learn that he had lost by one of the closest margins ever: 23 electoral votes. From left to right are Charles Evans Hughes (1862–1948), Elizabeth Hughes (1907–1981), Catherine Hughes (1898–1961), Helen Hughes (1892–1920), and Ellen Antoinette Carter Hughes (1864–1945). Missing from the family group is Charles Evans Hughes Jr. (1889–1950).

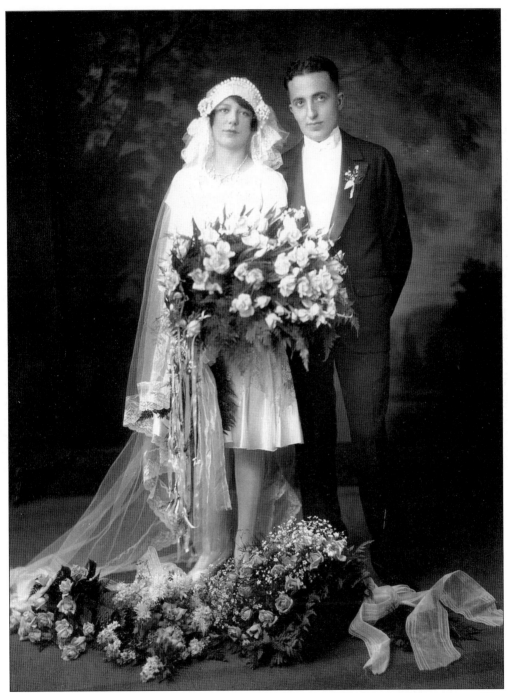

A KACZENSKI WEDDING, 1927. The bride and groom pose for their wedding picture. The Kaczenski family was one of many families of Polish and Eastern European heritage who began arriving on eastern Long Island in the 1880s. Families with names like Baiseyecki, Colinoski, Curincziny, Dombkowski, Goloski, Jubulinski, Masjeski, Modizeturski, Musnicki, Rondowski, Schusescki, Verniski, and Zabroski continued to arrive in Bridgehampton, adding to the already successful Irish and German immigrant communities that had settled before them.

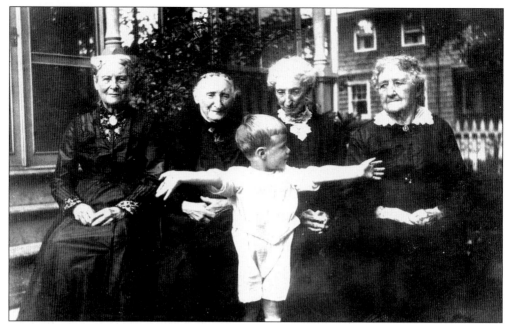

HOLROYD CURTS AND HIS GREAT AUNTS, C. 1920. Holroyd Curts was the son of Dr. and Mrs. Paul H. Curts, who lived in the Capt. Henry Huntting House. This photograph was taken in the front yard of that home. The house in the right background was built for one of the Tiffany boys in the early 20th century. From left to right are Mary Hildreth Hedges (1839–1925), Maria Ludlow (1852–1929), Holroyd Curts, Hattie Corwith, and Martha Huntting Worth (1863–1925).

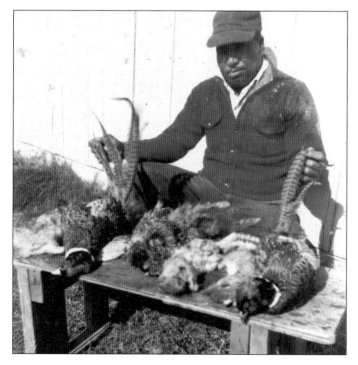

MORGAN WYCHE, C. 1925. Morgan Wyche attended the Hayground School and was a longtime employee on the Harold Rogers Farm in Hayground. He is pictured here c. 1925 with several pheasants, the result of a successful day's hunt.

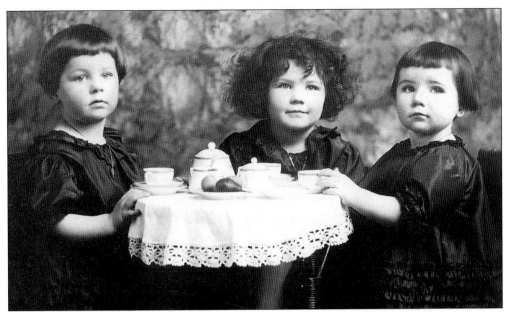

THE TEA PARTY, C. 1922. The Magee girls, Mary Agnes, Eleanor, and Barbara, are having a tea party. They were the daughters of Nora and Raymond Magee, who was instrumental in the establishment of the Queen of the Most Holy Rosary Church and served as president of the Lions Club. The family occupied a spacious home on the north side of Main Street that was later moved to Hedges Lane and then to its present location on Town Line Road.

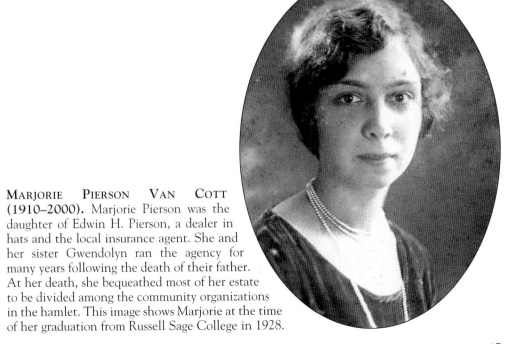

MARJORIE PIERSON VAN COTT (1910–2000). Marjorie Pierson was the daughter of Edwin H. Pierson, a dealer in hats and the local insurance agent. She and her sister Gwendolyn ran the agency for many years following the death of their father. At her death, she bequeathed most of her estate to be divided among the community organizations in the hamlet. This image shows Marjorie at the time of her graduation from Russell Sage College in 1928.

IRVING MARSHALL, C. 1984. Born in Bridgehampton, Irving Marshall (1893–1985) was the son of Frank Marshall and Nellie Cuffee Marshall, a member of the Shinnecock Indian tribe. He began working at the Bridgehampton Club as a caddie in 1901 at the behest of Fanny Hardacre, his father's employer, and became a successful teacher and golf pro there. Marshall was an excellent gardener and worked for a number of local residents in that capacity during his lifetime. An accomplished musician, athlete, and community leader, he was instrumental in helping to keep the Bridgehampton Grade and High School open when it was threatened with closure in 1975. A devout Presbyterian he served as an elder in the Bridgehampton Presbyterian Church from 1968 to 1969 and again from 1973 to 1975. At his funeral a special ceremony was performed by members of the Shinnecock Nation.

THE BRIDGE, C. 1900. This is the infamous landmark that gave Bridgehampton its name. The original bridge was constructed between 1686 and 1690 by Ezekiel Sandford, who had been hired by the town and was a wheelwright by trade. In 1699, the Colonial Assembly, realizing that the two precincts of Sagg and Mecox were now united, decided to officially name this enlarged precinct Bridge Hampton in honor of the bridge built to link them. The first church was located on the east side of the pond a little east and north of the bridge. The bridge pictured here, erected in the late 19th century, was replaced early in the 20th century by the present concrete one.

A VIEW OF BRIDGE LANE, LOOKING WEST, C. 1908. Bridge Lane meets up with Sagg Main Street in the distance. The houses, from left to right, are the Marconi station residence, the White-Klebnikov house, the John White farmhouse, and the residence of Dr. Coakley.

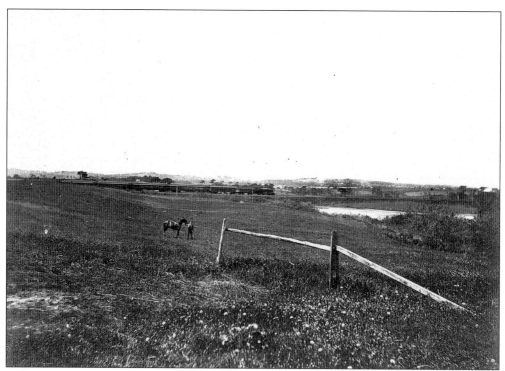

A BRIDGEHAMPTON LANDSCAPE, C. 1910. In this view, looking south, a Long Island Rail Road train steams its way west, just north of Long Pond and directly south of the Moraine Hill.

Four

HOMES

One of the earliest houses in Bridgehampton was built by Ezekiel Sandford (1648–1716). In 1678, the Southampton town trustees granted Sandford 15 acres of land on the northeast corner of today's Ocean Road and Bridge Lane, providing that he agree to remain in the town for seven years, follow his vocation as a wheelwright, and make wheels for residents "at a reasonable price." Almost every conceivable style of residence exists in Bridgehampton. Colonial, Federal, Greek Revival, Stick, and French Empire are just a few that are represented. From small to large, intimate to palatial, the houses of Bridgehampton express the position and personalities of the many generations of local residents (and summer residents) who have occupied them.

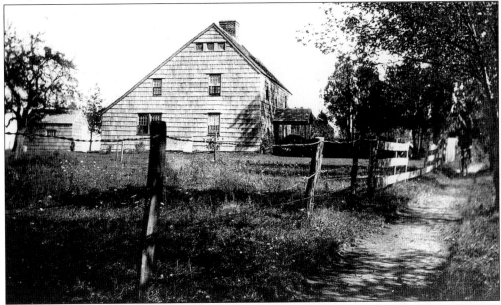

THE EZEKIEL SANDFORD HOMESTEAD, C. 1907. Ezekiel Sandford probably constructed his home c. 1680. The house was subsequently passed down in the male line for five generations. In 1890, the house was purchased for $10 by the Cincinnati branch of the family and remains in that branch today. The house, thus, has been in continuous ownership by the Sandford family for 10 generations. It is perhaps the least altered house of the period still standing in Bridgehampton.

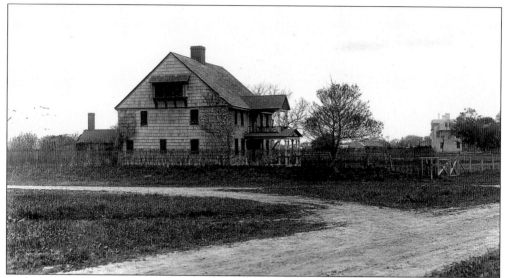

THE OLD WHITE HOMESTEAD, C. 1890. This house was originally constructed by Hezekiah Bower in 1730 and was sold to the White family in 1764. The house was purchased in 1882 by the Honorable Frederick W. Seward (1830–1915) and moved across the street to its present location, on the corner of Sagg Main Street and Bridge Lane. Seward was the assistant secretary of state under three U.S. presidents: Abraham Lincoln, Andrew Johnson, and Rutherford B. Hayes. In the 1930s, the house was purchased by Ross Nebolsine, whose descendants own the house to this day.

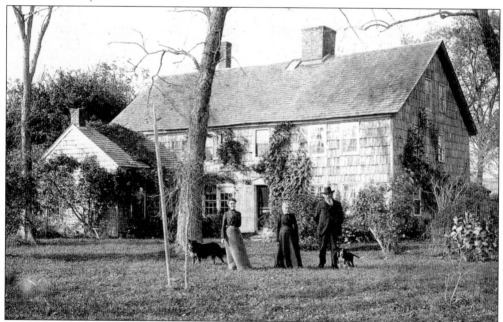

THE ZACCHEUS ROSE HOUSE, C. 1880. This home was constructed for Zaccheus Rose (1700–1760). The house, with its large interior chimney, stood between Hayground and Bridgehampton and was later owned by Zaccheus Rose's son Stephen Rose (1742–1806). Shown in front of the home are Charlotte Rose (b. 1854) and her parents, Henry Rose and Elisabeth Rose. The site of this house is today occupied by the Watermill Lumber building.

THE SWAMP (FIRST) PARSONAGE, C. 1890. This house, built *c.* 1730, is the oldest structure still standing on Sagaponack Road. Rev. James Browne (1720–1788) was the second minister of the Church of Christ in Bridgehampton, replacing Reverend White in 1748. Browne ministered to his flock until 1775, retiring shortly before the outbreak of the American Revolution and moving to his farm in Scuttlehole, where he died in 1788. Browne's house, located on the north side of Sagaponack Road, was known as the Swamp Parsonage or the First Parsonage. It served a number of later ministers, including Rev. Aaron Woolworth (1763–1821) and Rev. Amzi Francis (1793–1845), the last minister to live there. Reverend Francis built a new house on the corner of Ocean Road and Church Lane, the West Parsonage, in 1825. The old house was sold and became the home of Sylvanus Ludlow (1805–1891) and, later, of Charles T. Ludlow (1857–1934).

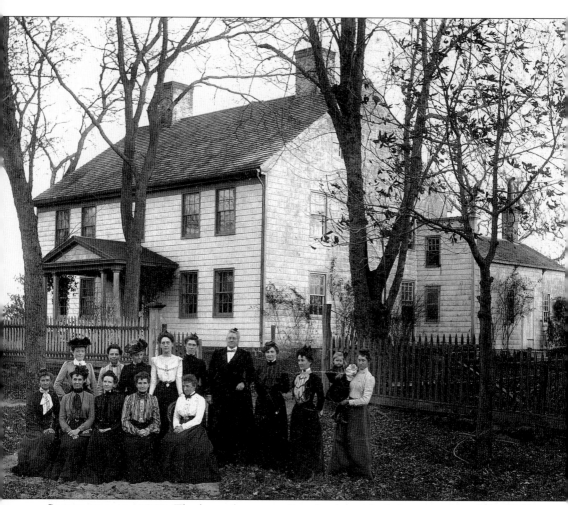

SAYRELANDS, C. 1880. The house known as Sayrelands was built by a member of the Halsey family *c.* 1734. In 1770, the house was purchased by Col. Nathan Post (1748–1803), captain of the armed sloop *Revenge* during the American Revolutionary War. Post was involved in the infamous lawsuit called the Fox Case, also known as *Pierson* v. *Post*. His son, Lodowick Post (1777–1842), later inherited the house. Also a captain, the son served under Gen. Abraham Rose in the War of 1812 and defended the port of Sag Harbor when the British attacked on July 11, 1813. The house was sold to Capt. Uriah Sayre (1792–1872) in 1832 by then owner John Pierson. Sayre was a whaling captain who went to sea at the age of 14. The house eventually came into the possession of Charles and Helen Niles, Helen Niles being a direct descendant of Uriah Sayre. Shown in front of the house are members of the Thimble Club.

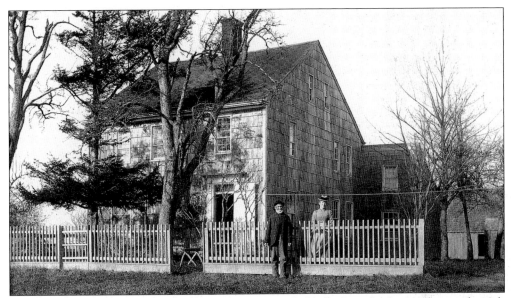

THE HENRY TOPPING HOUSE, 1902. This house, probably built in the late 18th or early 19th century, was located on the north side of Montauk Highway where the Poxabogue Golf Course stands today. Known as the Henry Topping house, it was owned by Stephen D. Wood (b. 1814), who is pictured here with his daughter Emma. Wood was probably a descendant of Jonas and Lydia Wood, who, in 1695, sold 10 acres of land in Sagaponack to Rev. Ebenezer White (1672–1756), the first minister of the Church of Christ.

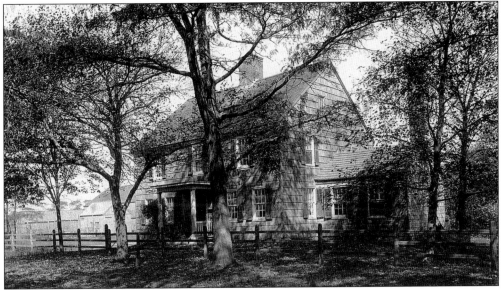

THE WOODRUFF-BISHOP HOMESTEAD, C. 1910. Originally located near the railroad tracks on Mitchell Lane, this house was built c. 1750 and was later occupied by Daniel Woodruff (1747–1825). It remained in the Woodruff family until Daniel Woodruff's daughter Abigail Woodruff (1781–1866) died. Not long after, the property was purchased by Jetur R. Bishop (1818–1889). Helen Bishop Hamlin (1896–1985) and her husband, Bryan Hamlin (1895–1978), moved the house to Quimby Lane in the 1960s. The large barns seen in the left background no longer exist.

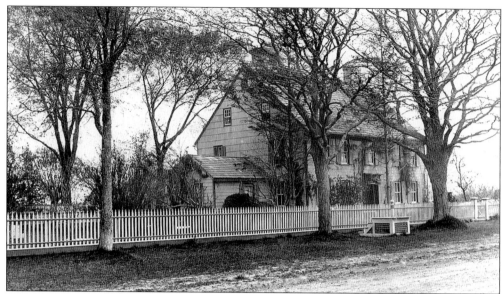

THE DEACON HEDGES HOUSE, HEDGES LANE. David Hedges (1744–1817) was one of Bridgehampton's most prosperous farmers and public servants. He served in the state legislature for seven years, was supervisor of the town of Southampton for 20 years, and was a member of the convention that ratified the U.S. Constitution in 1788. His home, known as the Deacon Hedges house, is distinguished by its two interior chimneys, a feature that is more commonly found in New England and shared by only one other house in Bridgehampton.

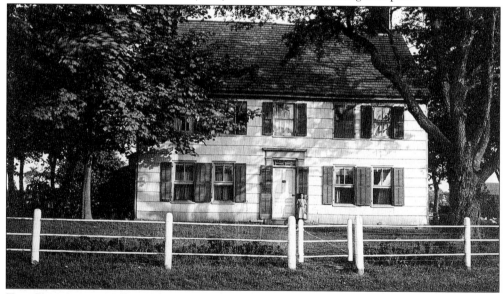

THE GEN. ABRAHAM ROSE HOUSE, C. 1910. Gen. Abraham Rose (1765–1843) is best known as the commander in charge of the defense of Sag Harbor during the War of 1812. Born in Bridgehampton in 1765, he was a soldier and officer during the American Revolutionary War (1776–1783) and was made a brigadier general in 1812. Rose was a surveyor by trade. His house, constructed in 1791, is located on Montauk Highway in Hayground. Standing on the front stoop is Louisa Brown, a descendant of the Rose family and the first president of the Bridge Hampton Historical Society.

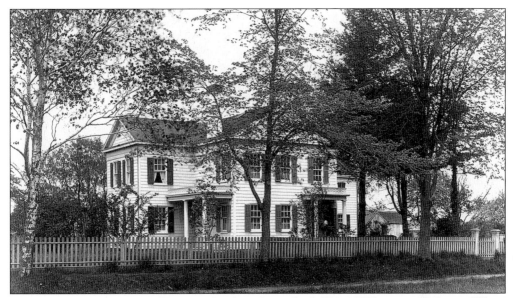

THE GURDEN CORWITH HOUSE. Gurden Corwith (1789–1877) married Susan White (1789–1873), with whom he had nine children. Their sons, Henry Corwith (1813–1888), Nathan Corwith (1816–1889), and John E. Corwith (1831–1898) all moved to Illinois where they made fortunes. Upon Henry Corwith's death in 1888, his wealth was estimated at $6 million. Possibly built as early as the 1790s, the Gurden Corwith house was sold in the 1960s to Frederick M. Mayer (1920–2001), who restored its Greek Revival style. Today the house is the Bridgehampton Inn.

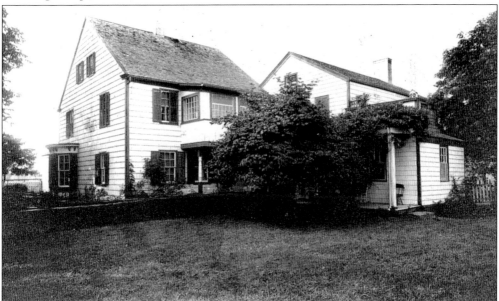

THE RUFUS AND EDWIN ROSE HOUSE (HAND BROTHERS FARM), c. 1900. This house was built by Nathan T. Cook c. 1802–1804 for Dr. Rufus Rose (1775–1835). Rose served in the American Revolutionary War as a doctor and surgeon. His son Edwin Rose was born in 1807 at Hayground. Following Edwin Rose's death, the house was sold to Capt. George Hand (1819–1887) and was the site of the Hand Brothers Farm until the early 1970s.

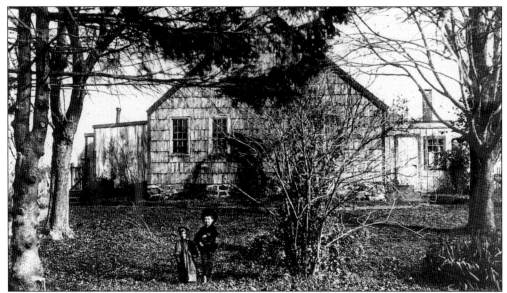

THE STEPHEN SAYRE HOUSE, C. 1890. Stephen Sayre (1832–1908) was a farmer who lived in Bridgehampton. He married Sarah Elizabeth Squires (1835–1876) of Water Mill in 1860, and lived in this house prior to the construction of a larger one nearby in 1871. Sayre's original house was moved to Foster Avenue and then to the west side of Ocean Road by Marjorie Pierson Van Cott (1910–2000), where it remains today. The children shown in the foreground are those of George Hildreth.

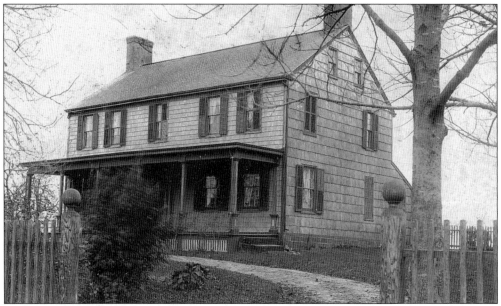

THE LEVI HOWELL HOUSE, C. 1900. Built between 1813 and 1814, the Levi Howell house is located on the corner of Ocean Road and Paul's Lane. Col. Levi Howell (1782–1863) was an officer in the War of 1812. The house was sold not long after its completion to Nathan T. Post (1840–1915) and was inherited by Post's daughter, Cora (1864–1949). The large beech tree that graces the lawn came from the *Louis Phillipe*, a ship that became stranded off Bridgehampton in 1842. The house is currently owned by Mr. and Mrs. Jeffrey Vogel.

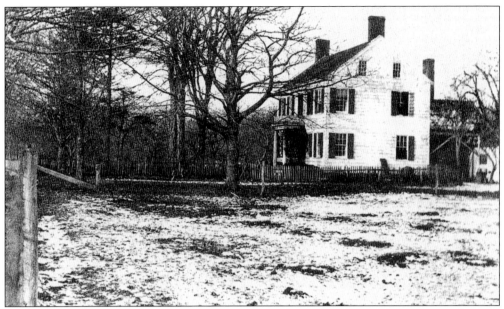

THE BENJAMIN FRANKLIN HOWELL HOUSE, C. 1910. Benjamin Franklin Howell was a descendant of Edward Howell, one of the founders of Southampton Township. The front portion of the house was constructed in 1836, and the rear wing dates to the late 18th century. The house is pictured in its Montauk Highway location. In 1983, the front portion of the house was purchased by Mr. and Mrs. Wallace Quimby and moved to Quimby Lane, where it stands today.

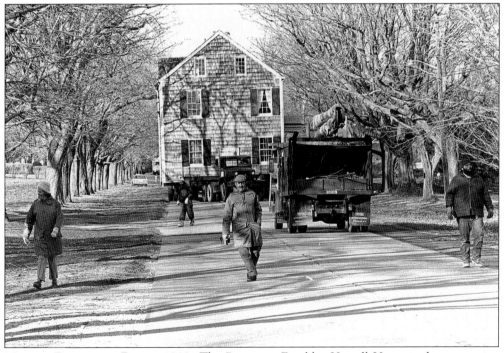

MOVING DOWN THE ROAD, 1983. The Benjamin Franklin Howell House is shown moving down the road to its new home.

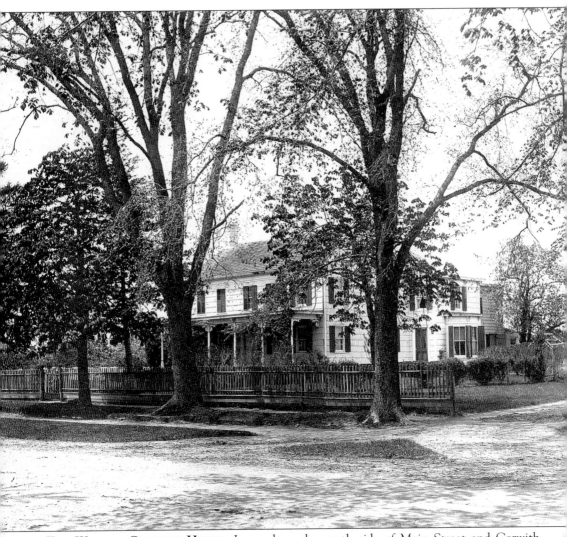

THE WILLIAM CORWITH HOUSE. Located on the north side of Main Street and Corwith Avenue, this Greek Revival home was built c. 1840 by William Corwith (1791–1872). The property was originally purchased by Henry Corwith (1758–1820) in 1784 from Capt. Edward Topping, a noted American Revolutionary War officer. Following William Corwith's death in 1872, the house was inherited by his son William Augustus Corwith (1825–1902). At the time of William Augustus's death, his widow, Susan Beard Corwith (d. 1912), lived in the house with her three daughters, Lucy, Anabel, and Cornelia Corwith. The daughters lived in the house for most of the rest of their lives. None of them ever married. Prior to moving to New Jersey in 1960, Cornelia Corwith presented the Hampton Library with the house, hoping that the library would move to this new location. That did not happen, and later the same year, the recently formed Bridge Hampton Historical Society began leasing the building. In 1972, the society purchased the house and established it as its headquarters and museum. Today, the house is regularly open to the public.

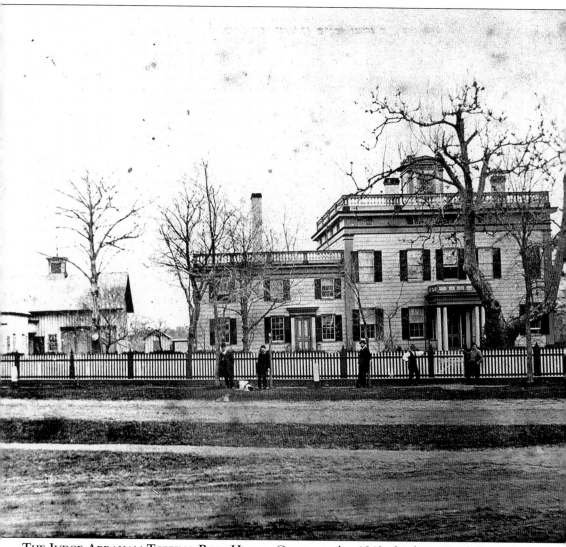

THE JUDGE ABRAHAM TOPPING ROSE HOUSE. Constructed *c.* 1842, this large Greek Revival home was built for Judge Abraham Topping Rose (1792–1857). Rose was the son of Dr. Samuel Rose and was known as a man of "brilliant talents." By the early 20th century, the Topping Rose house was the summer residence of Henry N. Corwith (1858–1944), a prominent businessman and local dairy farmer. The building later became the home of a series of popular restaurants and inns, including the Colonial Manor and the Bull's Head Inn. In 1970, the house was threatened with demolition to make room for construction of a Sunoco gas station, but newly adopted zoning laws saved it from the wrecking ball. Frances Carpenter, the owner of the house at the time, instead donated it to the Catholic Archdiocese of New York in 1972. In 1973, local auctioneer and antiques dealer Charlie Vandeveer purchased the house from the archdiocese with plans to restore it

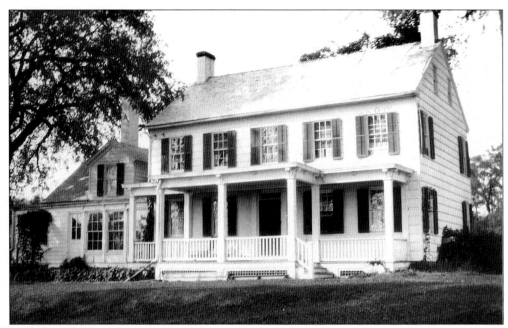

THE WILLIAM D. HALSEY HOUSE, C. 1920. William Donaldson Halsey (1860–1939) was one of Bridgehampton's most noted historians. He served as Southampton town historian and for years compiled stories, histories, and legends about Bridgehampton that were finally published in 1936 in his book *Sketches From Local History*. Pictured is his house, located at Scuttlehole and Brickiln Road.

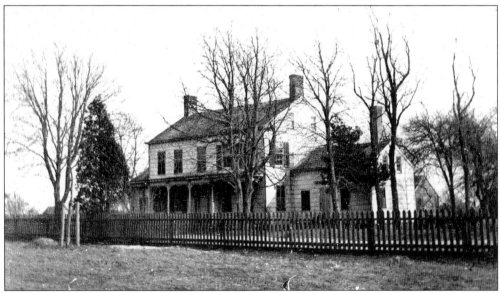

OLDFIELDS. In 1854, Gurden Pierson (1786–1866) hired a member of the Babcock family of East Hampton to construct Oldfields. The house was later owned by Pierson's son and daughter-in-law, Theodore (1821–1891) and Phebe Pierson (1831–1903). Following Phebe Pierson's death, William I. Halsey (1872–1959), an officer of the Esterbrook Pen Company, owned the house. In the 1960s, the house was sold to William G. Thompson of New York City, who restored it and made it his home for more than 30 years.

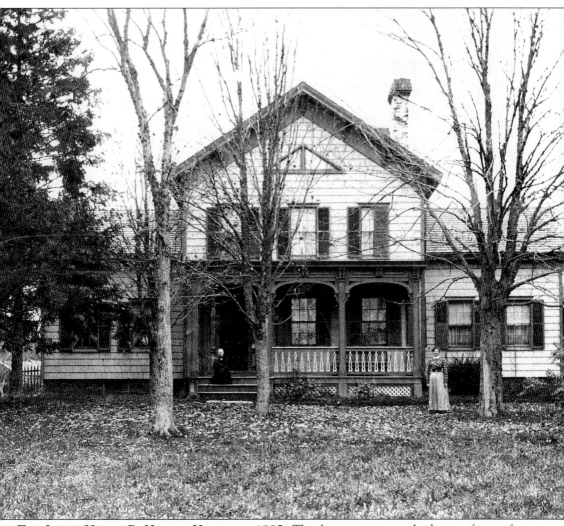

THE JUDGE HENRY P. HEDGES HOUSE, C. 1895. This house was once the home of one of Suffolk County's most important residents, a man who was an attorney, judge, and local historian. Judge Henry Parsons Hedges was born in 1817 in the hamlet of Wainscott, just east of Bridgehampton. He was first educated at Clinton Academy in East Hampton and later attended Yale University to study law. Upon being admitted to the bar in 1842, Hedges took up practice in Sag Harbor. He was a founding member of the Republican Party of New York State in 1856 and was elected to a county judgeship in 1865. Hedges remained in Sag Harbor until *c.* 1850, when he purchased a tract of approximately 131 acres on the east side of Ocean Road in Bridgehampton. His house, completed by 1854, was a mix of the Greek Revival and Italianate styles. After Hedges's death in 1911, William Brennan of Brooklyn purchased the house and property along Ocean Road. To this day, Brennan's descendants own this historic residence.

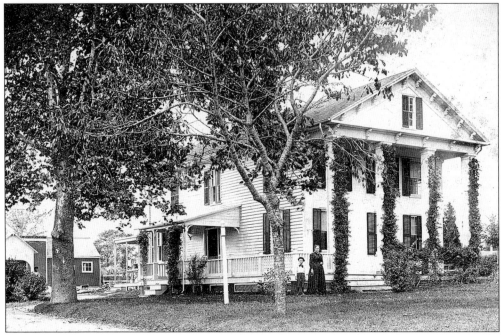

THE DR. LEVI WRIGHT HOUSE, C. 1890 (ABOVE) AND 1990 (BELOW). Dr. Levi Wright (1810–1883) lived in this elegant house on the west side of Ocean Road. In 1842, he joined the committee raising funds for the construction of a new Presbyterian church. Wright, a usually stern individual, was known on occasion to stop children on the street and talk with them in order to learn what they were thinking.

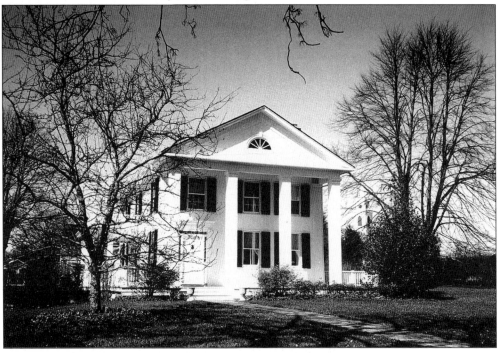

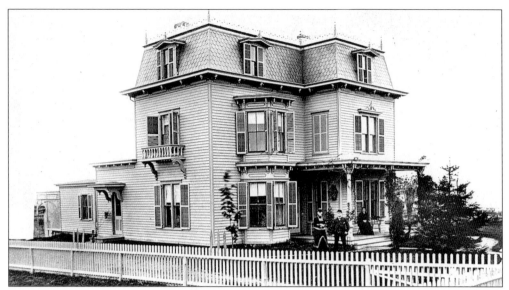

THE HUNTTING HOUSE. Built by Capt. James R. Huntting (1825–1882) in the 1870s on the east side of Ocean Road, this large house was designed in the Second Empire style, one of two built in that style in Bridgehampton. In 1913, James Huntting's daughter, Martha Huntting Worth (1863-1925), moved back into the house after selling her own residence. By 1931, Huntting House was a hotel, before becoming the office of Dr. Silas W. Corwith.

ROSE HALL, C. 1990.
Rose Hall was built for the Tiffany family c. 1875. Nathan Newton Tiffany (1812–1882) arrived in Bridgehampton and became a partner in the firm of Tiffany & Huntting, a local mercantile enterprise. The Tiffany home was later the home of Frederica G. Tiffany (1862–1956). Frederica Tiffany's daughter, Mary Palmer Tiffany Eagleton (1889–1980), ran a successful porcelain-painting studio in Bridgehampton for many years. The house, once painted bright red and known locally as the Red House, is now painted pink.

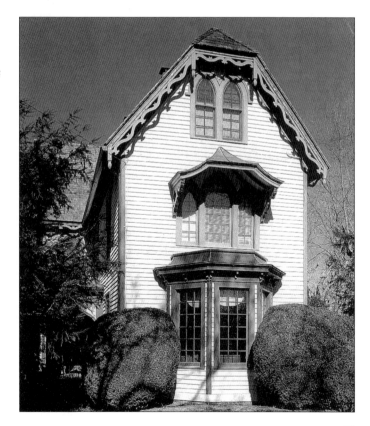

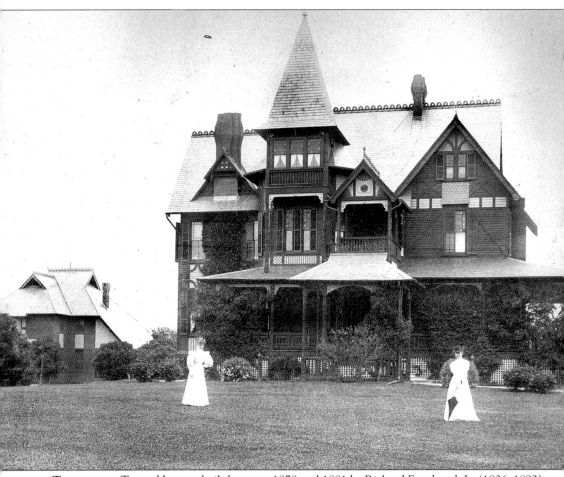

TREMEDDEN. Tremedden was built between 1878 and 1881 by Richard Esterbrook Jr. (1836–1892), who was the heir to the Esterbrook Pen Company of Camden, New Jersey. Esterbrook's wife, Antoinette Rose Esterbrook (1844-1925), known as Nettie, was raised in Bridgehampton and was the daughter of Judge Abraham T. Rose (1792–1857). The house was designed by architect Carlos C. Buck of Brooklyn in the Stick style, and it had a barn and carriage house. Painted deep red with green trim, the house stood out strongly against the green fields of Bridgehampton. It was described in a 1910 newspaper article as "one of the showplaces of the village." Following Antoinette Esterbrook's death in 1925, the attorney handling her estate was murdered, causing many difficulties in the settling of her will. Once the Great Depression set in, the house fell into disrepair. Mrs. John Berwind, the Esterbrooks' niece, purchased the house in 1939 and had it torn down by the local firm of A.W. Chapman.

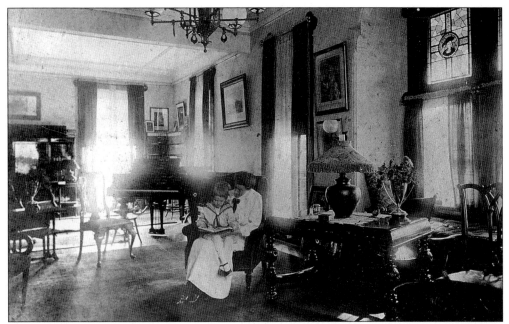

THE PARLOR AT TREMEDDEN, C. 1911. The parlor of the Esterbrook mansion, Tremedden, was 15 feet by 24 feet. Here it is shown sumptuously outfitted with Colonial Revival furniture, a grand piano, and beautiful stained-glass windows. Seated in the chair reading are Antoinette Esterbrook Carter (1869–1919) and her youngest son, Paul Stuart Carter (1909–1981).

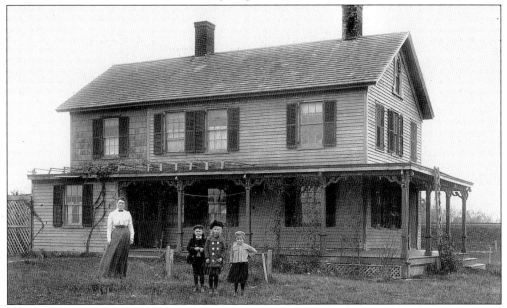

THE DICKINSON HOUSE, C. 1900. Built on Butter Lane, this is the Dickinson house. It was home to David Topping Dickinson (1862–1935) and his wife, Louise Halsey Dickinson (1862–1950), who is shown with Marjorie Dickinson Dredge (1897–1989), Helen Quimby Bishop Hamlin (1896–1985), and probably Edward C. Dickinson (1896–1954). Marjorie Dickinson Dredge was the 17th postmaster for Bridgehampton, serving from 1936 until her retirement in 1955.

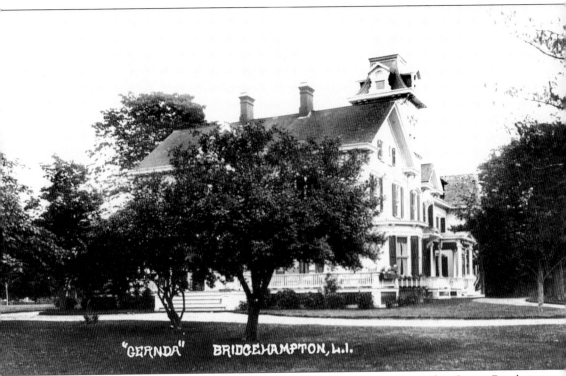

"GERNDA" BRIDGEHAMPTON, L.I.

GERNDA, THE MARCEL KAHLE MANSION, C. 1905. The first house on this Ocean Road site (known as the West Parsonage) was that of the widow of Rev. Amzi Francis (1793–1845), Mary S.H. Francis (1808–1897). Following her occupancy, the house was acquired by William H.H. Rogers (1843–1900), who was involved in the paper-bag manufacturing business in Brooklyn. Rogers had the house redesigned between 1876 and 1882 according to plans by George H. Skidmore of New York City. Marcel Kahle (1858–1909) purchased the house c. 1904–1905 and greatly enlarged the residence. Kahle was the president of George Borgfeldt and Company of New York City, the importing firm that later became famous for its toys. The newly expanded house was christened Gernda, which means "green fields" in German. Following Kahle's sudden death in 1909, the house was occupied by his widow, Julie Kahle (1858–1931). Eva Eno used the house for a private school between 1932 and 1934. It was demolished in 1940–1941. The residence had 13 bedrooms and 6 maids' rooms, plus a caretaker's cottage, carriage house and stable, greenhouse, chicken house, dovecote, playhouse, and other buildings.

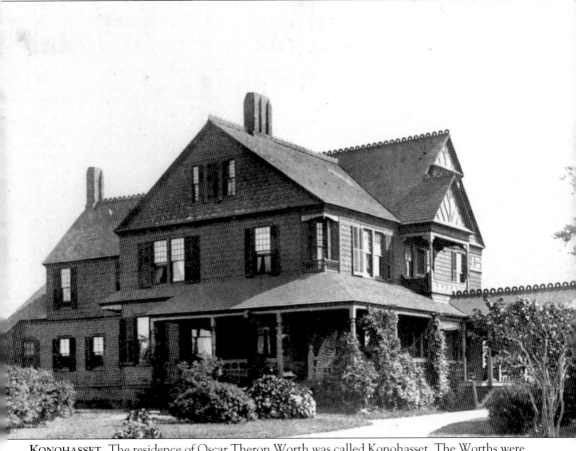

KONOHASSET. The residence of Oscar Theron Worth was called Konohasset. The Worths were originally from Nantucket. They moved to Southold, Long Island, and made their fortune in the whaling industry. The Stick-style mansion they built was named for a ship that they lost in the Pacific in 1846. The ship *Konohasset* was purchased in Boston in 1845. Captained by Theron Bunker Worth (1814–1867), it was a 426-ton vessel that was wrecked at Pell's Island on May 24, 1846. Theron B. Worth's only surviving child, Theron Oscar Worth (1860–1907), moved to Bridgehampton and probably utilized his sizable inheritance to construct Konohasset *c.* 1880. Like the Esterbrook house, Konohasset had a billiard room on the third floor. Worth died suddenly in 1907, and his widow, Martha, sold the house in September 1913 to the Bradley family. The hurricane of 1938 caused extensive damage to the house—so much damage that the Bradleys had Konohasset torn down in 1940–1941. Although the main house is gone, the stable and carriage house and the caretaker's cottage survive today as residences.

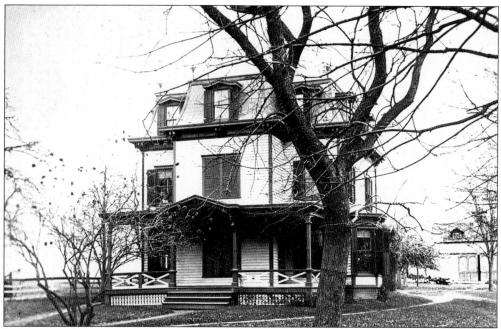

THE PROF. LEWIS W. HALLOCK HOUSE, 1890. This large, Second Empire–style home was built for Prof. Lewis Hallock *c*. 1880. The house was prominently located on Ocean Road just south of the Bridgehampton Academy. It was one of several important houses designed and built by local carpenter Ichabod Sheffield Seabury (1821–1907). The house was moved to Sagaponack Road by Hallock's son and daughter-in-law, Arthur (1892–1949) and Bessie Hallock (1895–1970), to make way for the Beebe Windmill and Berwind Memorial Green, which were dedicated in 1935.

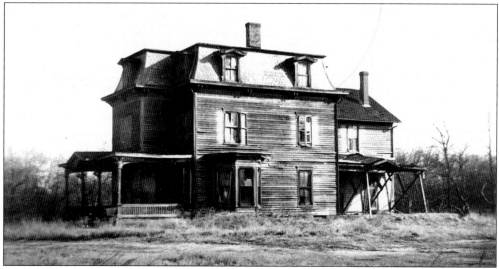

THE HALLOCK HOUSE, C. 1970. Many people offered money to Bessie Hallock to purchase and restore the house, but she refused to sell it to anyone. Following her death, the house was burned to the ground as a practice fire for the Bridgehampton Volunteer Fire Department. It is most notable as being the house that inspired local resident and famous cartoonist Charles Addams in his creation of a residence for the family in his *Addams Family* cartoons.

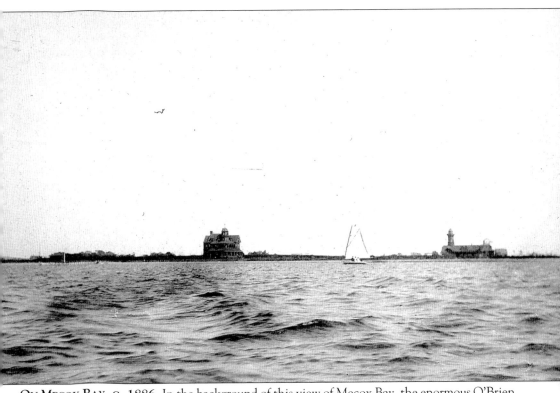

ON MECOX BAY, C. 1886. In the background of this view of Mecox Bay, the enormous O'Brien mansion (left) and the Bascom mansion loom on the horizon. The O'Brien house, named Listowell after a small town in Ireland, was built by Joseph O'Brien, one of the most successful dry good merchants in Brooklyn. His store, located at 151 Atlantic Avenue, first opened in 1863. By 1884, O'Brien had expanded his business to include five continuous storefronts, employing 150 workers and grossing nearly $750,000 a year. O'Brien first came to Bridgehampton c. 1870 on the recommendation of his doctor and found it so delightful that he regularly returned to board with his family. The huge four-story mansion, completed c. 1887, with elaborate porches, balconies, and a tower, was an impressive site to behold. The house was badly damaged in the hurricane of 1938 and lingered for nearly another 20 years before it was finally demolished in 1954.

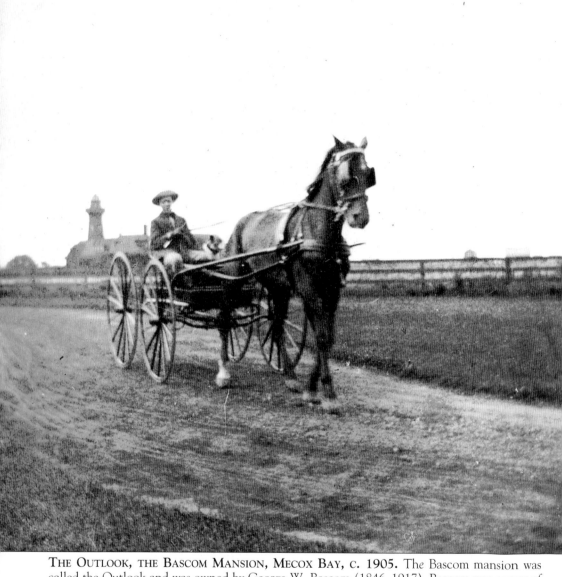

THE OUTLOOK, THE BASCOM MANSION, MECOX BAY, C. 1905. The Bascom mansion was
called the Outlook and was owned by George W. Bascom (1846–1917). Bascom was owner of
the Bascom Theater Ticket Agency, one of the two largest companies in New York City that
sold tickets to Broadway shows. He was a noted collector of early English coins, and his
extensive collection of early English strikes was sold at auction in London in 1914. He built this
massive estate on Horsemill Lane in the late 1880s, next door to the mansion of Joseph
O'Brien. This image shows a young woman riding away from the main house, designed with its
own lighthouse tower in the background. The estate also included another house, built c. 1907,
as well as a carriage house, boathouse, and a myriad of other support buildings. The main house
and its buildings were foreclosed on in the late 1930s and purchased by Harry Ludlow, a local
farmer, who requested that the remaining estate buildings be torn down as part of his purchase
agreement. Today, the site of the estate is occupied by a large cornfield.

THE McCASLIN HOUSE, c. 1893. This house was completed for Francis McCaslin in October 1888. Decorative yet modest, it stood south of the Halsey & McCaslin Blacksmith Shop. The tall pumping tower (right) served as the first water company in Bridgehampton, providing water for 10 houses in the area. Standing in front of the house, from left to right, are George McCaslin, Lena Ruppel McCaslin (1866–1940), F. Edgar McCaslin (1890–1953), and Francis McCaslin (1857–1937).

THE HENRY L. SANDFORD HOUSE, c. 1904. Henry L. Sandford (1863–1949) built this house on the corner of Bridge Lane and Ocean Road in 1890 and raised his family there. Sanford's daughter Florence King Sandford Hansen (1899–1988), shown with the family dog Spot, inherited the house after his death. The house was sold out of the Sandford family in 1968.

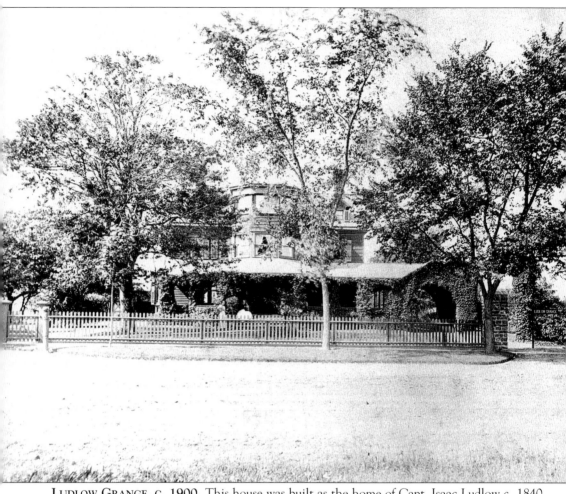

LUDLOW GRANGE, C. 1900. This house was built as the home of Capt. Isaac Ludlow *c.* 1840. Ludlow (1807–1871) was a noted captain of Sag Harbor's whaling fleet. The house later passed to his widow and then to his daughter Fanny and her husband, William Hardacre (1824–1891). The Hardacres were married at the house on October 19, 1882. Not long afterward, they began an extensive renovation of the house, which included the addition of a tower, porte-cochere, and a large, sweeping porch. The interior of the house, originally Greek Revival in design, also was thoroughly remodeled in the Victorian style. The house was the home of Fanny Ludlow Hardacre until her death in 1933, at which time the house passed to her niece. It was later the home of Robert Keene, the longtime town historian for Southampton.

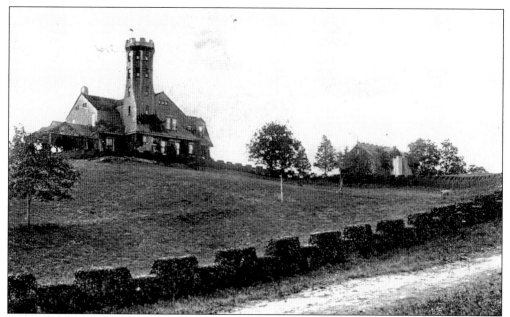

DULCE DOMUM, C. 1900. Dr. John L. Gardiner was a scion of the famous Gardiner family of Gardiner's Island. Upon retiring from active practice, Gardiner constructed this home on the Moraine Hill in 1891, naming it Dulce Domum. The distinctive house, with its 40-foot tower, allowed sweeping views of the surrounding farmland. Known locally as "the castle on the hill," the property even had the privet hedge trimmed to resemble medieval crenellations.

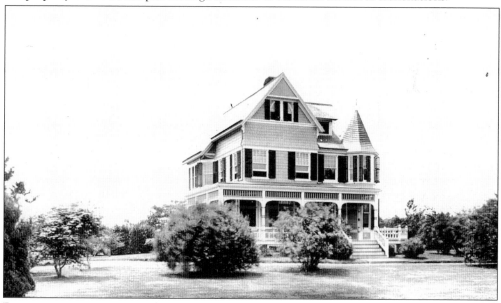

BLYTHEBOURNE, C. 1900. John E. Heartt, a native of Troy, New York, came to Bridgehampton and built this house, naming it Blythebourne. It was later known as Trees, due to the many large trees that grace the property—linden trees that were salvaged from the wreck of the *Louis Phillipe*. In 1941, noted art historian George Nebolsine purchased the home. Nebolsine's brother Ross also purchased a home in Bridgehampton. George Nebolsine's family sold the house in the 1970s.

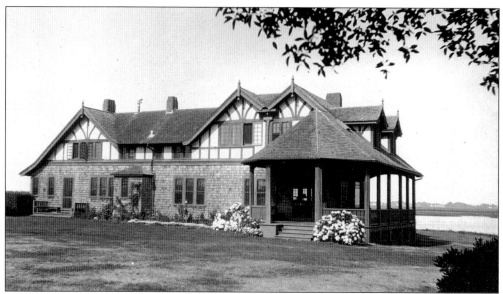

ANNESDEN. Edward E. Quimby grew to love Bridgehampton after a visit during the 1880s. He built a house c. 1900 and christened it Annesden (Annie's Den) on the Pond. The house was designed in the Tudor Revival style by the Mann and MacNeille of New York City. Annesden was regularly utilized by the Quimby family and its descendants until it was demolished in the early 1990s. The avenue today known as Quimby Lane was originally the main drive of the estate.

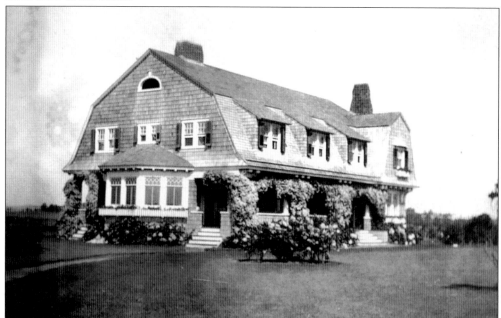

HOPEWELL, 1907. Located on Sam's Creek near the end of Ocean Road, Hopewell was designed by James E. Ware and Sons of New York City and was completed in time for the 1906 summer season. The house, designed in the ever popular Shingle style, was built for Frederick V. Clowes (1872–1954). Many members of his family stayed there, including his brother, noted author Ernest Clowes. Not long after Frederick Clowes's death, the house was torn down.

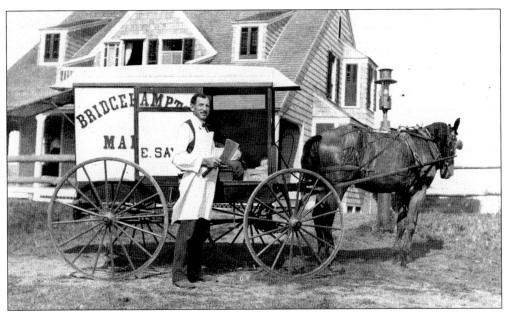

THE BUTCHER WAGON AT HALSEYCOT, C. 1909. Eugene Sayre (1869–1953) and his butcher wagon are shown in front of Halseycot, the residence of Mr. and Mrs. Stephen Bolles Halsey, on Daniel's Lane. Like many merchants in town, Sayre brought his wares to residents. Halseycot was built in the 1890s. Stephen Bolles Halsey was the son of Stephen Alling Halsey, the founder of Astoria, New York, and a direct descendant of Josiah Stanborough, who first settled Bridgehampton in 1656.

DRIFTWOOD, C. 1908. Shown shortly after its construction, the Carter beach house, Driftwood, was owned by Antoinette Esterbrook Carter, daughter of pen magnate Richard Esterbrook Jr. Antoinette Carter died in 1919, leaving the house to her young son, Paul Carter. The home was decorated in the Arts and Crafts style, with beautiful Mission-style oak furniture and interiors. Later sold, the house was washed out to sea in a nor'easter that struck Long Island in 1962.

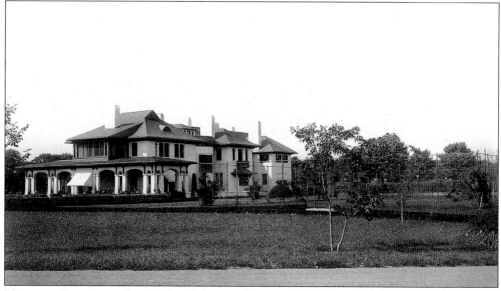

MINDEN. Sometime after 1903, Katherine Murray Wood Berwind (1873–1945) and her husband, John E. Berwind (1854–1928), were looking for a place to build an estate. Katherine's aunt, Antoinette R. Esterbrook, sold part of her landholdings to the Berwinds. Minden, the Berwind estate, was completed in 1913. Katherine Berwind used Minden until her death. Later, the estate was sold to the Presbyterian Church to be used as a retreat center. Later still, it was run as a spa.

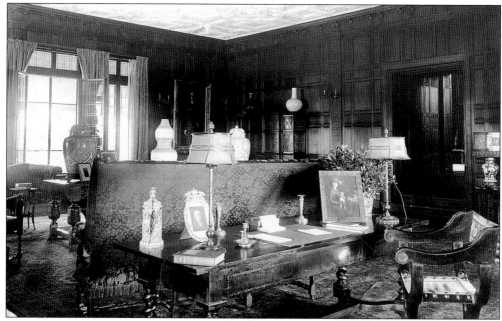

MINDEN INTERIOR, 1913. This interior photograph of Minden, taken at the time the house was completed, shows the beautiful Jacobean interior decoration that provided a contrast to the flowing, rounded lines of the stuccoed, Mediterranean-style exterior. Although one might think that the interior decoration would have been done by a New York City decorator, it actually was done by the Bridgehampton company of George S. De Puy.

Five
PUBLIC BUILDINGS
AND CHURCHES

The earliest public building in Bridgehampton was the First Presbyterian Church, better known as the Meeting House. It stood just west of the bridge on Bridge Lane and served the community from the late 1600s to 1737. By 1800, the first library in Bridgehampton had been established on Ocean Road, and in the late 1800s a new, modern facility was built. Other religious institutions appeared: first, the New Light Church, soon followed by the Methodist church. During that time Atlantic Hall provided a place for shows, potluck suppers, church socials, and plays; in the 1900s, the Bridgehampton Community House took over that role. The fire department expanded in the 1900s, and more churches were established. Today, Bridgehampton boasts more than 11 community organizations, all helping to make it a better place.

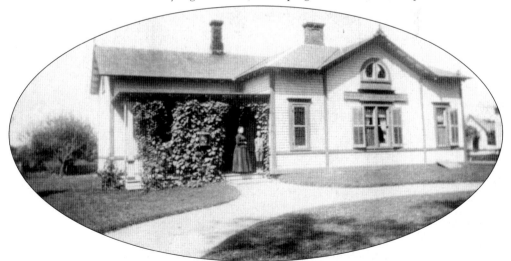

THE HAMPTON LIBRARY, 1888. The Hampton Library of Bridgehampton was organized in 1876. William Gardiner donated the lot for the building stands and $10,000 towards its construction, as did his cousin, Charles Rogers. When the library opened in 1877, it had 3,523 volumes and was the largest library on Long Island east of Brooklyn. Shown is the original building, with its now lost circular drive, before the construction of a second story.

ATLANTIC HALL, 1931. Atlantic Hall was constructed on Ocean Road as a social hall in the 1880s. It was used for many community events, including school district meetings, suppers, fairs, dances, talent shows, and even traveling shows. Later moved to Main Street on the corner of Corwith Avenue, the building outlived its usefulness after the Bridgehampton Community House opened in 1923. In 1934, the hall was torn down. To the right in this view are Rogers & Hedges Garage and Basso's Restaurant.

THE BRIDGEHAMPTON COMMUNITY HOUSE. Originally sponsored by the American Legion, the push to construct the Bridgehampton Community House building was primarily made by local resident James Truslow Adams, author of *Memorials of Old Bridgehampton*. The whole community pledged money for the building, with the most generous gift coming from Mr. and Mrs. John E. Berwind. The Corwith sisters provided the land, and the new building was dedicated on May 30, 1923. It quickly became a popular and widely used facility for movies, plays, dances, and other events.

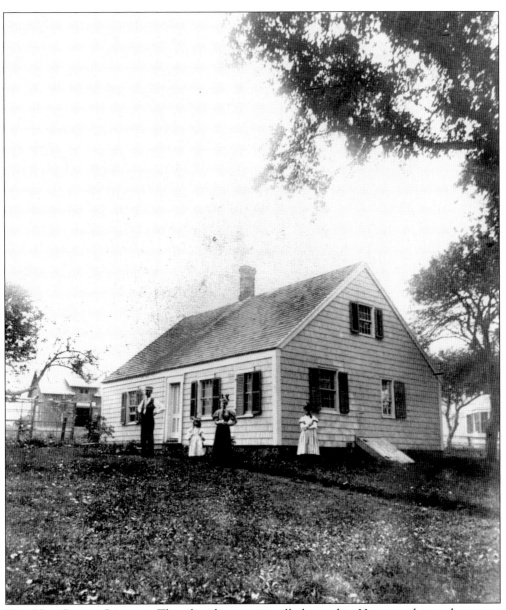

THE NEW LIGHT CHURCH. This church was originally located in Hayground near the corner of Montauk Highway and New Light Lane. Constructed in 1748, the New Light Church was established at the time the Great Awakening was sweeping the nation. The congregation in Bridgehampton was led by Rev. Elisha Paine (1692–1775). Paine was originally from Cape Cod and worked as a lawyer until 1742, when he was swept up in the Great Awakening and decided to become a minister. He came to Long Island and was ordained as the first (and only) minister of the New Light Church in Bridgehampton. He served as the minister there until his death in 1775. The congregation dispersed not long afterward, and the church was converted to a residence. The building was later moved from New Light Lane to Ocean Road and became the residence of Edwin P. Rogers (1859–1933), as well as the location where he ran his livery business. The house was acquired by the Kahle-Peck family in the early 1900s and is still owned by descendants of that family.

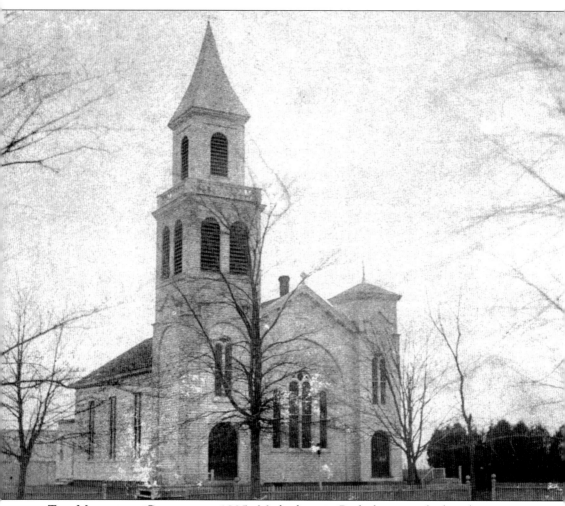

THE METHODIST CHURCH, C. 1895. Methodism in Bridgehampton had its beginnings in 1815, the year in which circuit rider Rev. John Reynolds preached at the Hayground Schoolhouse. The first permanent Methodist church was built on Ocean Road in 1820 and was used until 1833. A new church was constructed on the south side of Montauk Highway close to the site of the Episcopal church. Once the new Bridgehampton Methodist Church was complete, the old one was sold to William Corwith, who moved it to his property to be used as a kitchen. By the late 1860s, the Methodist congregation had yet again outgrown its space, so an expansion was in order. The church was moved in 1871 to its present site on the corner of Halsey Lane and Montauk Highway, where it was greatly enlarged and improved.

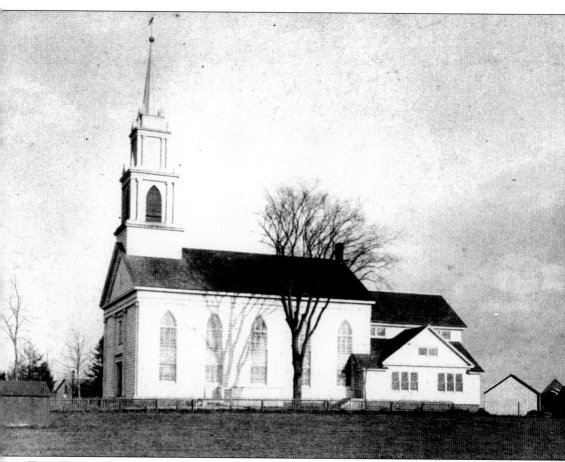

THE THIRD PRESBYTERIAN CHURCH, C. 1888. The Third Presbyterian Church was constructed in 1842 on the south side of Montauk Highway in the middle of the town. The structure replaced the second church, built in 1737 on the north side of Sagaponack Road. Designed in the Greek Revival style, most likely by Nathaniel Rogers (1787–1844), the new building was dedicated on January 17, 1843, with more than 2,000 people in attendance. At the time the church was completed, its steeple was the second tallest on eastern Long Island. The church is shown before the addition of the porte-cochere on the east side, the porch on the north, the clock, and the stained-glass windows donated by Henry Corwith and Mrs. William Hardacre in 1897. Clearly visible on the side of the church are the original Gothic-point, multi-light, clear glass windows.

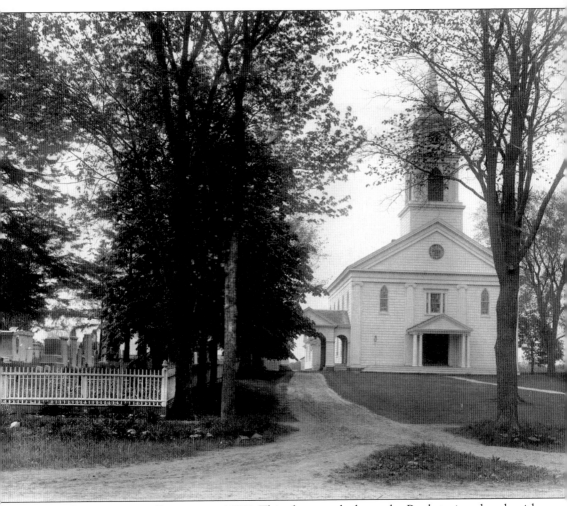

THE PRESBYTERIAN CHURCH, C. 1907. This photograph shows the Presbyterian church with its recently installed clock and stained-glass windows. The clock was a gift donated by Mrs. John Corwith of Galena, Illinois. John E. Corwith (1831–1898) went west to make his fortune. He retired to Chicago c. 1870 and was the owner of a 2,000-acre farm in Hancock County, Iowa, at the time of his death. The clock, donated by his widow, was made by the Seth Thomas Clock Company. It was installed in 1906, following the reconstruction of the tower that had been destroyed during a storm in the winter of 1904. The cemetery, with the large cedars, is shown at the left. Although surrounded by lands owned by the Presbyterian Church, the Old Cemetery has no association with it. It has been an independent burying ground since the 18th century. Most of the trees scattered throughout the cemetery were lost in the 1938 hurricane.

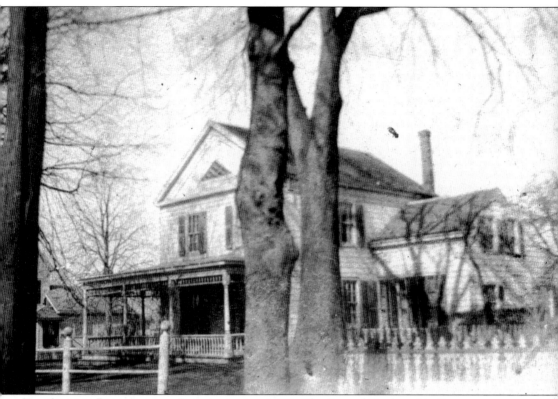

THE SECOND PRESBYTERIAN PARSONAGE, C. 1915. The Second Presbyterian Parsonage was constructed on the north side of Main Street opposite the Presbyterian church. It was built for the fifth minister, Rev. Cornelius Edgar (1811–1884), in 1845–1846. The building was last used for its original purposes during the pastorate of Rev. Arthur Newman (1853–1924), who served as the ninth minister from 1883 until 1924. The building no longer stands in its original location.

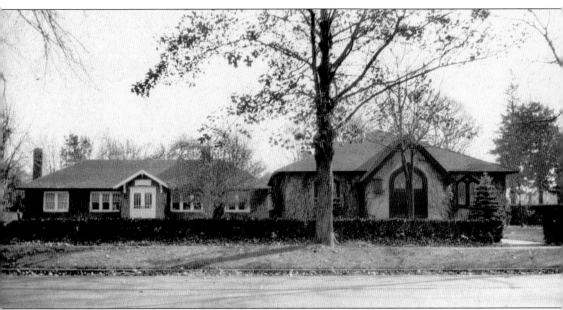

ST. ANN'S EPISCOPAL (MISSION) CHURCH. The first services of St. Ann's Episcopal (Mission) Church, originally a mission of St. Luke's in East Hampton, were held in the Old Sandford Homestead in 1906. Mrs. Sherlock donated a parcel of land on Ocean Road in 1907 for the construction of a more permanent home for worshipers. The old golf clubhouse from Bridge Lane was moved to that land and outfitted for services later that year. In 1908, the Atlantic House, which had served as an inn, was purchased and the chapel was moved to that property on the south side of Main Street. The old inn served as the first rectory. Later, a house from Sagg that was donated by the Deshler family was moved to the site to serve as a rectory, and the old Atlantic House was removed. The parish house was constructed in 1915 entirely at the expense of John E. Berwind for the benefit of the church and community. During the 1970s, the chapel was renovated, including the addition of a small bell tower.

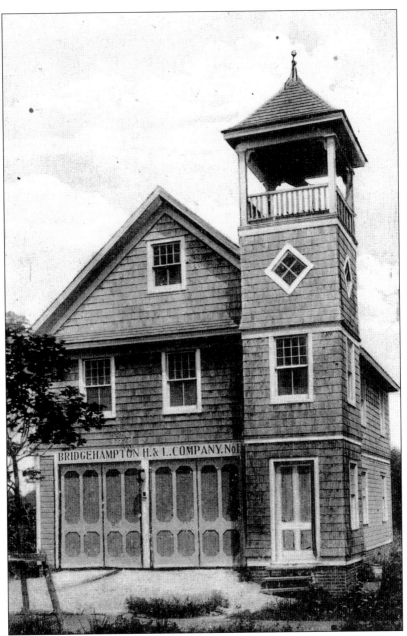

THE FIRST BAPTIST CHURCH OF BRIDGEHAMPTON, C. 1925. The Baptist Church was founded in 1922 as a small group who met in homes to pray. By 1924, under the leadership of Rev. H.D. Strotter, the group became fully organized and purchased the old Bridgehampton Hook & Ladder Company building, on Corwith Avenue, to serve as its chapel. (Organized in 1895, the fire department constructed this building in 1908 and stayed here until 1923; the department then moved south of the highway to the recently completed Community House and, later, to its current location, a new building south of the Community House.) The Baptist congregation grew rapidly and numbered well over 150 members by the 1950s. Outgrowing this church the congregation moved to a new location on Sag Harbor Turnpike. Today, the building on Corwith Avenue is occupied by the Dan Flavin Art Institute.

QUEEN OF THE MOST HOLY ROSARY CATHOLIC CHURCH. Prior to the construction of Queen of the Most Holy Rosary Catholic Church, Roman Catholics living in Bridgehampton had to travel to Sag Harbor for services. In 1912, under the direction of Rev. Francis J. O'Hara, Raymond Magee and Paul Roesel were given permission to begin raising funds for the construction of a permanent house of worship. James Hildreth of Amagansett purchased land from the Corwith sisters and then sold it to Roesel and Magee, who transferred it to the diocese. According to local tales, at the time almost no one wanted a Catholic church in Bridgehampton, and the land had to be bought secretly. In 1913, construction began, based on a design by F. Burrall Hoffman, under the direction of Donnelly and Corrigan of Southampton. Services were held weekly in Atlantic Hall until the new building was completed. On July 11, 1915, Rt. Rev. Charles E. McDonnell, bishop of Brooklyn, dedicated the new church. The rectory (right) was completed in 1924. The original spire located above the crossing of the church was lost in the 1938 hurricane.

Six

SCHOOLS

The earliest schools were held in the homes of local residents. In the 18th century, the two-chimney schoolhouse was erected on the green. It was the first institution established for higher learning in Bridgehampton. In conjunction with the first library, founded in the 1790s by local schoolteacher Stephen Burroughs, Bridgehampton could now offer a reasonable education for its youth. By the end of the first quarter of the 19th century, local school districts were established and new buildings constructed in each of the small communities that made up Bridgehampton: Hayground, Scuttlehole, Sagg, and Mecox. The Bridgehampton Academy, founded in 1859, expanded educational offerings; however, after half a century of operation it fell victim, along with the small community schools, to the rise of publicly funded school facilities. The 20th century saw the establishment of consolidated districts and the creation of a modern, streamlined educational system for Bridgehampton.

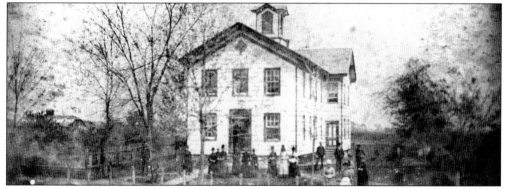

THE BRIDGEHAMPTON ACADEMY, C. 1880. The Bridgehampton Academy opened its doors in 1859 in a new building designed by local carpenter Ichabod S. Seabury. Between 1860 and 1872, the academy had several principals. In 1872, Prof. Lewis W. Hallock took over as principal and remained head of the academy until it closed. During his tenure the school was expanded and granted an official charter from the state of New York, and the name was changed to the Bridgehampton Literary and Commercial Institute, more befitting an institution that offered many advanced classes. The academy closed at the end of the 1907 school year. The building was divided into two sections and sold at auction. Hallock purchased one part, and the other older portion was sold to a local farmer and moved to Montauk Highway to be used as a farmhouse. The building was abandoned in the 1980s and sat vacant until recently, when it was acquired by the owner of Cozy Cottages in East Hampton and moved to that site, to once again be used as a house.

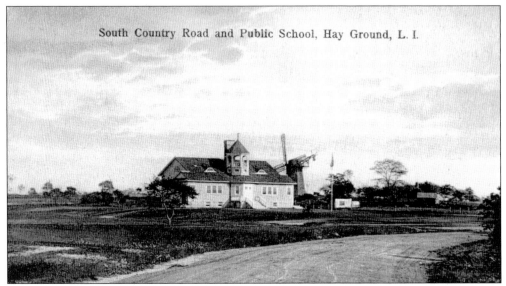

South Country Road and Public School, Hay Ground, L. I.

THE HAYGROUND SCHOOL. Located on the north side of Montauk Highway on the corner of Hayground Road, this school was constructed in 1891 to replace an earlier building. It was in use until 1946, when the district ceased to exist. Later, the building was used by the Knights of Columbus and then by a local church. The building currently houses an antiques shop. In the background, the old Hayground Mill and mill cottage can be seen.

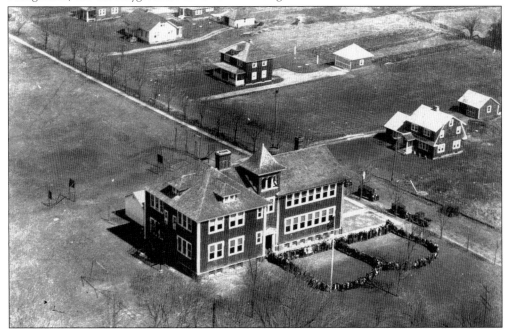

THE FIFTH BRIDGEHAMPTON SCHOOL, C. 1925. The fifth Bridgehampton School was built on the corner of School Street and Church Lane to replace the fourth school, which had been moved to Wainscott in 1908. The school was expanded c. 1920 with an addition to its eastern part. Shown are students forming a "B" for Bridgehampton. The school was made obsolete by the construction of the present school on Montauk Highway in 1931. The fifth school was demolished in 1934 and replaced by a baseball field and new firehouse.

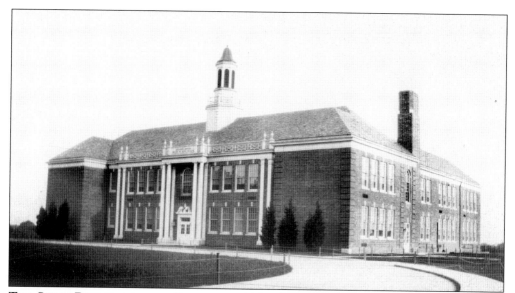

THE SIXTH BRIDGEHAMPTON SCHOOL, C. 1931. By 1927, the fifth school could no longer handle the growing population of Bridgehampton. The school board proposed the construction of a new addition in the Art Deco style, but that was voted down by the local people. Instead, a new Classic-style school was favored, and a new site on Montauk Highway was acquired. The New York City company Tooker and Marsh was hired to design the building, and in 1931, the school opened to its first classes.

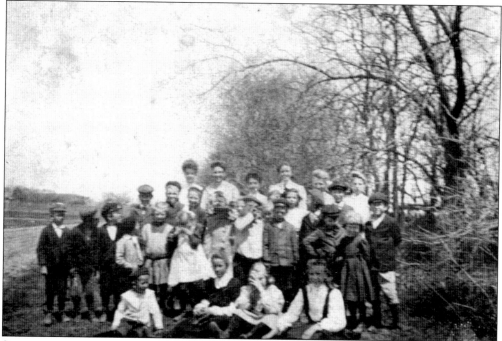

STUDENTS OF THE SCUTTLEHOLE SCHOOL, C. 1906. These students of teacher S. Havens pose for a picture, probably taken right outside of the schoolhouse on Scuttlehole Road. The school was built in 1903 and closed in 1920, when District No. 18, the North District, was dissolved.

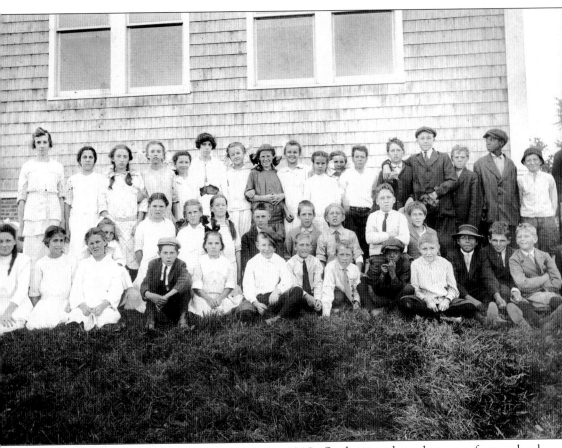

A BRIDGEHAMPTON SCHOOL PICTURE, C. 1912. Students and teacher pose for a school photograph. From left to right are the following: (front row) Sara Hildreth Burgess, Gwendolyn Pierson Griffing, Katherine Mayer Reed, Pearl Doran, Louise Bennett, Lemuel Howell, Rosamund Mayer Dadelman, Augusta Halsey Osborn, Almira Topping Wilford, Russell Hedges, John Naylor, Norman Sandford, Merritt Miller, George Edwards, John Hildreth, Albert Marshall, Eugene Sandford, James Hopping, Warren Sayre, Reginald Cuffee, Edward Mayer, Theron Worth, and Kenneth Eggelston; (back row) Addie Williamson, Irene Gangi, Louise Conklin Simons, Beatrice Hildreth Marik, Clara Schenk Raynor Wiggins, Mildred Masterson Topping (teacher), Ella McNamara McLauglin, Lucille Fahy Corrigan, Mae McNamara Cassidy Shanahan, May Nichols Nielson, Llewellyn Sayre Curry, John Hedges, Clifford Edwards, John McNamara, Ralph Squires, Cortland Marshall, Edward Brennan, and William McCaslin.

THE GRADUATING CLASS AND THE PRINCIPAL, C. THE 1920S. This is the graduation photograph for one class at the fifth Bridgehampton School. Only four people graduated that year, all girls. With them is Neil Quackenbush, the school principal.

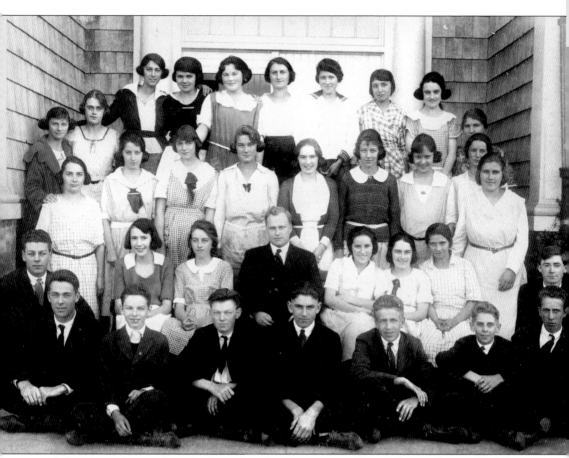

A BRIDGEHAMPTON SCHOOL PICTURE, OCTOBER 1921. From left to right are the following: (first row) John Hildreth, Pierson Hildreth, Frederick Norton, Benjamin Foster, Pierson Topping, Carroll Rogers, and Jack Burrell; (second row) Edgar Talmage, Marie Hildreth, Emily Maran, Neil Quackenbush (principal), Marjorie Jones, Agnes Murray, Marjorie Maran, and E. Ronald Halsey; (third row) Rosamund Mayer, Augusta Halsey, Hazel Hildreth, Katherine Murray, Nellie Maran, Margaret Topping, Carol Gregory, Dorothy Scheider, and Almira Topping; (fourth row) Llewellyn Sayre, Irene Cummings, Althea Kehl, Sara Hildreth, Mary Conklin, Kathleen Collins, Louise Bennett, Gwendolyn Pierson, Elizabeth Talmage, and Marguerite Ruppel.

Seven

THE SEA

From the beginning, the sea has always been one of the most important factors in Bridgehampton's development. Early settlers eagerly divided any whales that washed ashore, while others relied on ships for their livelihoods and for the goods they were so desperately seeking from ports around the world. Later, the sea excited a new group: those interested in escaping the smoky, dust-filled air of nearby cities and factory towns. They came to Bridgehampton to renew their bodies, minds, and spirits and to forget their woes, even for a little while. The deep blue sea and the cool breezes it brought with it were a welcome relief. A darker side of the sea, its ability to destroy and defeat, also reared its ugly head, as one ship after another became stranded along the shore, always hoping to float off but often remaining forever.

A WALK ON THE BEACH, C. 1888. The attractive beaches were one of the primary reasons that Bridgehampton became a desirable summer destination. Here, a family has taken its carriage down to the beach. The driver keeps pace with the family, in case someone tires of walking and wishes to be taken back to the boardinghouse. In 1888, there were only a few private summer homes in Bridgehampton. Most people rented whole houses or boarded in individual rooms.

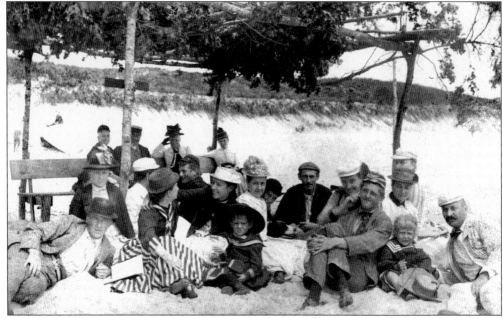

A BEACH ARBOR, C. 1885. Another popular activity during the summer season was the construction of beach arbors. These arbors, made of branches and cut timber, protected summer visitors from the sun. They were set up just beyond the dunes, near the ocean. Here, the Twyeffort family and their friends relax away from the sun.

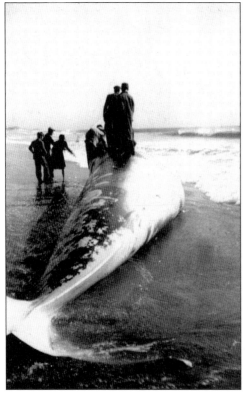

A BEACHED WHALE, C. THE 1920S. During storms, whales often would become misguided and end up stranded along the beaches of Bridgehampton. In the 17th century, local settlers would divide up the whale to use for making supplies and foodstuffs. Here, a number of people look on, as others take a stand atop the beached mammal.

THE STEPHENS BATHHOUSES, C. 1898. These bathhouses were built by E. Forrest Stephens (1843–1926), the last captain (1915) of the Life Saving Station before it became the U.S. Coast Guard Station. Erected on the east side of Ocean Road near its terminus, the bathhouses were used by the public for changing into and out of bathing suits. One group of bathhouses was reserved for men, and the other, for women. These bathhouses were used until the Bathing Pavilion was constructed around the time of World War I.

THE SAGG BEACH PAVILION AND BATHHOUSES, C. 1896. Like Bridgehampton, the small hamlet of Sagg also had a coastal pavilion complex, where residents could change into their bathing clothes before going down to the beach. The pavilion, itself (left), was a place to get out of the sun and enjoy other outdoor events.

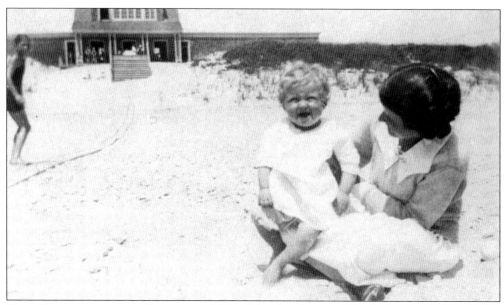

TWO BLANCHES AT THE BEACH, C. 1921. Blanche Sorzano Worth (1899–1985) and her daughter Blanche Worth Siegfried enjoy a day at the ocean. They are sitting on the beach in front of the original Bridgehampton Bathing Pavilion, which was built around the time of World War I and destroyed in the nor'easter that struck Bridgehampton in March 1962.

THE OX TRAIL APPEARS, 1960. An early wheeled cart pulled by oxen created this permanent mark in a layer of silt on the coast near Bridgehampton. Resident Howard Hand looks at the marks that were made during the earliest years of Bridgehampton's settlement. The site was uncovered when Hurricane Donna pulled away a great deal of beach sand from the coast. It is believed that these marks could have been made during the removal of timbers from a shipwreck.

THE MARCONI STATION, SAGAPONACK, c. 1903–1905. The Marconi station was set up in 1903, with a 150-foot tower. As its range was only 100 miles, it was used primarily to make contact with ships entering or leaving the port of New York. After a brief period of time in service, the tower was removed and the station closed. The house, where the attendants lived, has always known as the Marconi Cottage.

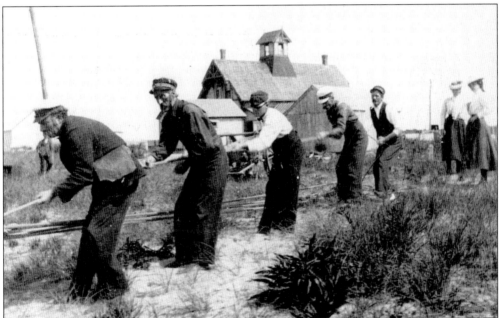

LIFESAVING PRACTICE, 1900. Capt. John N. Hedges (1847–1931) (left), his "No. 1 man" E. Forrest Stephens (1843–1926) (second from left), and three other men from the Life Saving Service practice pulling a towline, while two women look on. Stephens was the last captain of the service prior to its conversion into the U.S. Coast Guard.

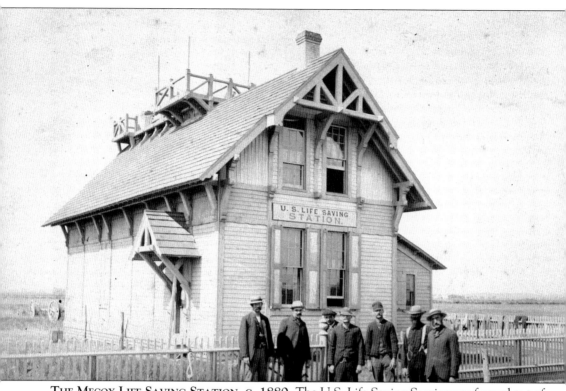

THE MECOX LIFE SAVING STATION, C. 1880. The U.S. Life Saving Service was formed out of the U.S. Revenue Marine and Life Saving Benevolent Association, which had been formed in 1849. The Revenue Marine had buildings along the coast that were loaded with supplies and provisions, but no men. In 1872, men and suitable living quarters became standard, and so the Life Saving Service truly began. The Revenue Marine and Life Saving Benevolent Association had a small garagelike structure in Mecox as early as 1849. The Mecox Life Saving Station was built c. 1877, based on an 1875 building plan that was utilized up and down the south shore of Long Island. The men pictured here are members of the crew. The Life Saving Service eventually became the U.S. Coast Guard, and many stations were either closed between 1911 and 1914 or continued to operate under the new service. The Mecox station was converted to a U.S. Coast Guard Station c. 1915. It received extensive damage during the hurricane of 1938. In 1947, the building was sold and moved to Noyack to serve as a house.

THE LOOKOUT HOUSE, C. THE 1920s.
The lookout house was located near the
Life Saving Station at the end of Ocean
Road. From atop the dunes, an attendant
could watch more closely for signs of
trouble from ships in distress and could
also keep warm during the winter
months. Local resident Blanche Sorzano
Worth (1899–1985) sits on one of the
rescue boats.

THE COAST GUARD TOWER, C. THE 1920s.
The Coast Guard tower stood just east of the
Bathing Pavilion at the Bridgehampton Beach.
The tower disappeared c. 1947, and by the late
1950s, all that was left were the concrete piers
and their wooden pilings. Occasionally, the
remains of the pilings appear after storms.

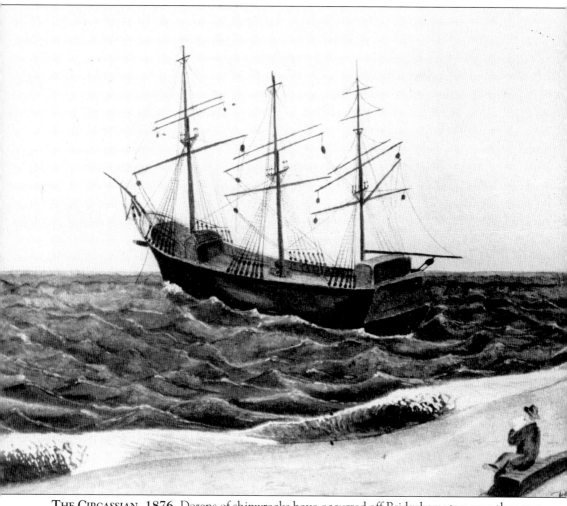

THE CIRCASSIAN, 1876. Dozens of shipwrecks have occurred off Bridgehampton over the years, but perhaps the most infamous wreck was the *Circassian*. The *Circassian* was a 1,741-ton, full-rigged iron ship, 280 feet in length. It arrived off Bridgehampton on December 11, 1876. It became stranded on a sand bar and sat there for two weeks, while crews attempted to remove it. While emptying the ship, the salvagers neglected to remove cargo evenly from within the hold. The middle portion of the hold was empty, while the two end sections were dangerously loaded with cargo. This proved too much for the vessel, and at 3 a.m. on December 29th, 1876, the *Circassian* suddenly broke into two pieces. At 4 a.m., the remains of the ship careened to port. The iron mizzenmast and the rest of the vessel settled into the sea, with crew members still holding on to the rigging for dear life. Only 4 men of the 32 on board survived the sinking, and only 3 of them actually lived to tell their tale.

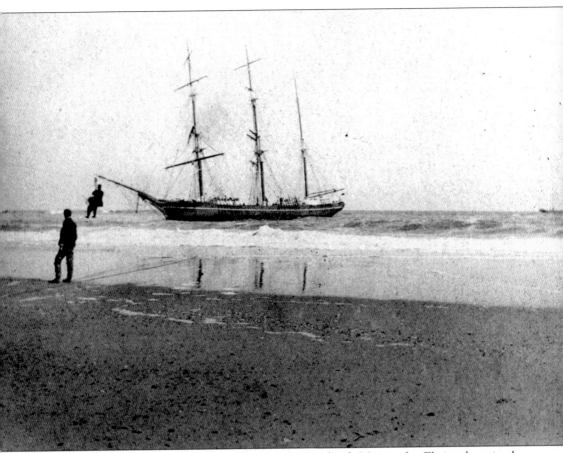

THE ELMIRANDA, 1894. A three-masted bark from Portland, Maine, the *Elmiranda* arrived offshore near Wainscott on April 21, 1894. The bark was named in honor of two sisters, Elmira and Miranda. On that April evening, the ship was first spotted by J. Everett Hand of the Georgica Life Saving Station, who quickly alerted the Mecox Station of the wreck. According to J. Howard Hand, the ship's cook had gotten into the captain's cabin in all the excitement and retrieved a bottle of aquavit, a sort of cordial water, made of beer, strongly hopped and well fermented. Apparently unwilling to leave the bottle behind, the cook hung it around his neck and proceeded to come ashore. Although buried by two waves while making the crossing, the cook arrived safely, with a parrot in his pocket and the bottle of aquavit still around his neck. The *Elmiranda* remained beached, with 15 feet of water inside it. The following Tuesday a tug and lightener arrived on scene, disposed of 50 tons over the side, and freed the ship.

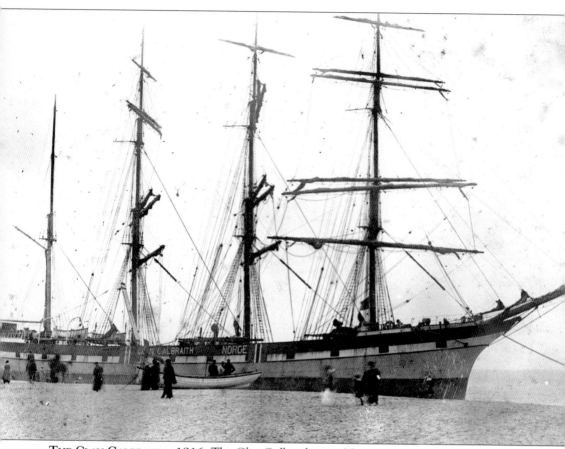

THE CLAN GALBRAITH, 1916. The *Clan Galbraith* was a Norwegian four-masted iron bark that weighed upwards of 2,000 tons. It ran aground near Flying Point Beach on July 22, 1916. It was located so close to the shore that people could board her at low tide without any great difficulty. A rope ladder hanging off the ship helped to facilitate "unwanted visitors." The crew, numbering 22, was easily rescued, and the ship sat on the beach for about two weeks until it was salvaged and removed for repairs. Those who visited the ship while it was aground said so many people came to the site that seemed like the "Riverhead Fair in the old days." The *Clan Galbraith* was lucky, but that luck was not to last. The ship was reoutfitted, and during World War I, it was sunk by the German navy. According to local historian Ernest Clowes, it was "probably the largest sailing vessel ever grounded along this coast."

Eight

EVENTS AND
CELEBRATIONS

Every small town loves its parades, its banquets, and its social activities, and Bridgehampton was no different. By the late 19th century, with the summer colony booming, everyone was here to have a good time in "Old Bridgehampton." Most events were fun. They included the firing of the cannon on the Fourth of July, parades celebrating the rich past of the hamlet, clambakes, baking contests, and fairs. Sometimes events took place that marked disasters or tragedies, but these were few and far between. Mostly, the celebrations that occurred in Bridgehampton were just that, celebrations—markers of events that should be looked forward to and long remembered.

THE REMAINS OF BABCOCK'S PHARMACY, APRIL 3, 1898. On April 2, 1898, Babcock's Pharmacy burned to the ground, nearly taking the neighboring Hampton Library with it. The library was saved only through the industrious efforts of the Bridgehampton Fire Department. The library trustees voted to make a substantial donation to the fire department in honor of its quick actions.

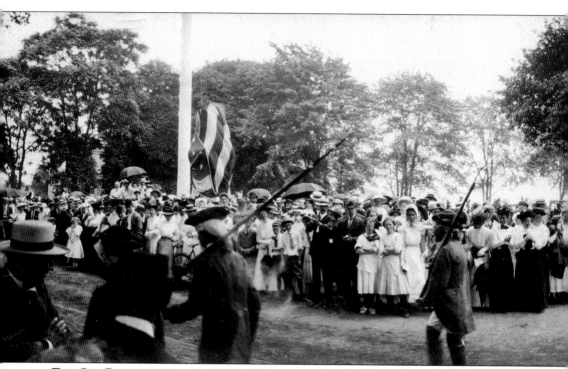

THE OLD REVOLUTIONARIES, 1910. This panoramic view shows the group known as the Old Revolutionaries marching past the flagpole in Bridgehampton during the 250th anniversary celebrations. The new monument has not yet been unveiled and is still wrapped tightly with a

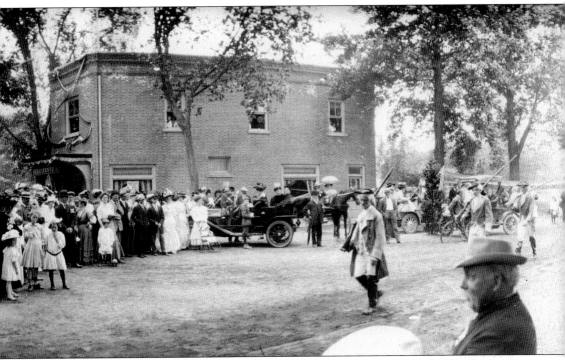

large American flag. In the right foreground is C. Hampton Aldrich (1852–1912), the local undertaker and building contractor who served as chairman of the anniversary celebration. In the right background is D.L. Chester's store, today the American Bistro.

ALL DECKED OUT, 1910. Getting decked out in the finest garments to attend the 250th anniversary parade would have been expected of those who anticipated hobnobbing with one of the associate justices of the U.S. Supreme Court.

THE MONUMENT. This monument was erected at the intersection of Ocean Road and Montauk Highway as part of the 250th anniversary celebrations. It was dedicated by Charles Evans Hughes (1862–1948), who was at the time the former governor of New York as well as an associate justice of the U.S. Supreme Court. The monument commemorated the founding of Bridgehampton, the American Revolutionary War, the War of 1812, and the Civil War.

THE FIREMAN'S CARNIVAL, C. 1911–1912. Clowns, performances, and a great feast were always a part of the Fireman's Carnival in Bridgehampton. The first carnival was held in 1911. The money raised by the carnival played a very important part in meeting the financial needs of the Bridgeport Fire Department. This field was located behind the old Sandford homestead on Ocean Road.

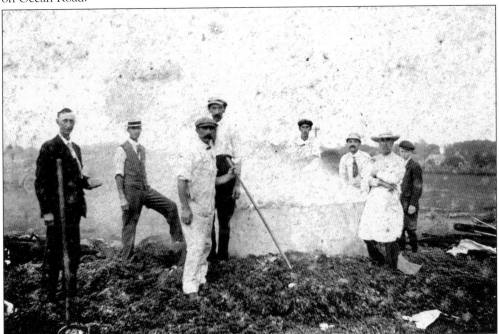

THE CARNIVAL CLAMBAKE, C. 1911–1912. At this Fireman's Carnival clambake, clams were buried underground in a pit, where a fire steamed them until they were ready to eat. The attendants pose for a photograph, as the steam rises from the ground.

SCENES FOR A FILM, HAYGROUND, 1916. Famous star Mary Pickford talks to members of the film crew during the shooting of scenes for her new film *Huldah from Holland*. It was one of a series of films the actress did based on the lives of immigrant women. The primary reason the film was shot in Hayground was the Hayground Mill (background): the small Dutch village, with its faux houses, had to be set up near a windmill.

A MODEL SCHOOL, C. THE 1930S. A Junior Order of United American Mechanics parade float is seen here. A model of the Wainscott School, one of the smallest in New York State, forms part of the float, along with the slogan "Maintain Our Public Schools." The float is a large truck, decorated with flowers and American flags. These images were taken at the Strong family farm in Wainscott. The little boy seen in the back of the truck is Carlton Strong.

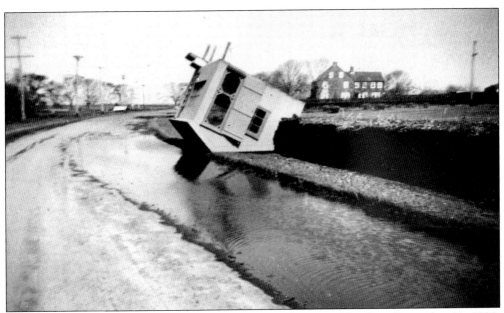

WASHED UP, SEPTEMBER 1938. The hurricane that hit Long Island on September 21, 1938, was the worst since the hurricane of 1915. Many houses were lost and much suffering was felt across eastern Long Island. Here, the Phineus Holt Playhouse is shown washed up onto Ocean Road. The Holts had a large house down on Sam's Creek.

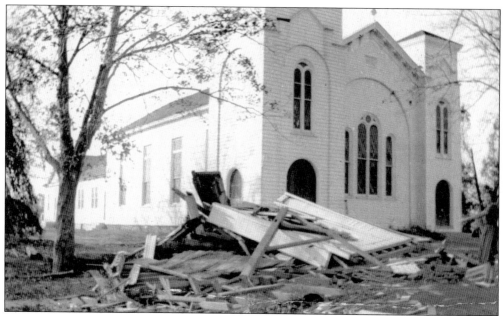

THE TOPPLED TOWER, 1938. The large east tower of the Methodist church lies strewn about the church grounds after being toppled by the hurricane of 1938. The tower was rebuilt not long after, but on a much smaller scale.

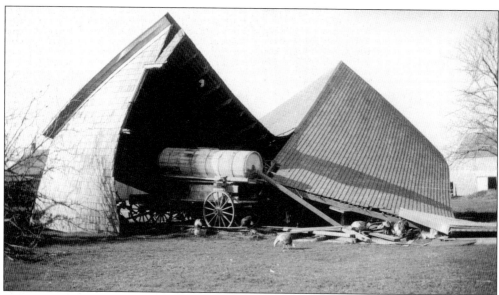

A RESHAPED SHED, SEPTEMBER 1938. The metal storage shed at Gilbert Rogers's place, on Sagg Main Street, was completely bent and pulled apart by the hurricane of 1938. Inside the barn is one of the old-fashioned fertilizer wagons, which at one time were fairly common across Long Island.

THE STORE, C. 1939. In 1956, Bridgehampton celebrated its 300th anniversary. As part of that anniversary, the hamlet had a week of festivities including a parade, pageant, and other events. As part of the pageant, many participants dressed up in period-style clothing. Pictured here are some of those participants, including members of the Topping, Babinski, and Elliston families.

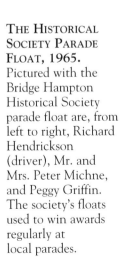

THE HISTORICAL SOCIETY PARADE FLOAT, 1965. Pictured with the Bridge Hampton Historical Society parade float are, from left to right, Richard Hendrickson (driver), Mr. and Mrs. Peter Michne, and Peggy Griffin. The society's floats used to win awards regularly at local parades.

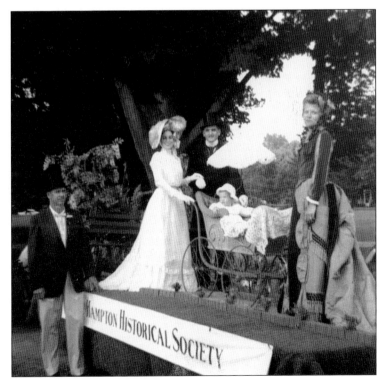

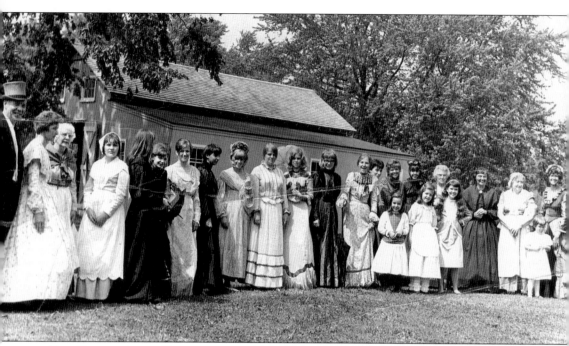

THE BICENTENNIAL CELEBRATION, 1976. Along with the rest of America, Bridgehampton residents held huge celebrations in 1976 in honor of the 200th anniversary of the founding of the United States. As in 1956, a pageant was held, and many local residents dressed up in old clothing or period-style clothing for the event. Pictured outside the Strong Wheelwright Shop, from left to right, are the following: (children, in front) Lisa Ann Michne Bordeaux, Denise Griffin, Betty Jane Sandford, and Elisabeth Hopping; (back row) Richard B. Sandford, Ethel V. Sandford, Louisa B. Sandford, Darah Smith, Susan Skretch Wiess, Patti Welles Brown, Theresa Dombkowski Walker, Margo Rana, Nancy Barbour, Barbara Skretch Brayson, Marilyn Musnicki, Susan Willis, Diane Guyer, Betty Gale Barnes Michne, Peggy Hildreth Griffin, Wendy Lowe Bulter, Dorothy Rogers Miller, Betty Wilson King, Louise Conklin Simons, Morgia Dumhan Hopping, and John Norris Hopping Jr.

Nine
SPORTS AND LEISURE

Bridgehampton had numerous leisure time activities in earlier days. For the most part, they were tied to church events, such as picnics, sermons by visiting ministers, or even religious revivals. These would have been rarer than the most important form, visits with neighbors. A trip to Wainscott or Sag Harbor to see relatives or friends was a welcome retreat from the hard work on the farm. In the late 19th century, with the arrival of the summer residents, Bridgehampton's eyes were widened to new ways of spending free time. The tennis club and golf clubs were formed, and the bathing pavilion opened as the beach became the place to be seen. The train arrived, making it possible to cheaply and easily travel to other destinations. The Mohonk House in upstate New York was a popular destination for Bridgehampton residents wanting to get away. Sports were extremely popular, especially football and baseball. Baseball became important enough that a local team was formed that regularly competed regularly across Long Island. In the 20th century, Bridgehampton became best known for its basketball teams, for which it is still known for today.

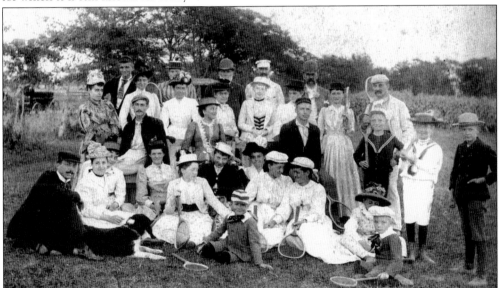

THE BRIDGEHAMPTON TENNIS CLUB, C. 1885. This club preceded what eventually became the Bridgehampton Golf and Tennis Club and, later, the Bridgehampton Club. Among the group shown here *c.* 1885 are members of the Twyeffort family.

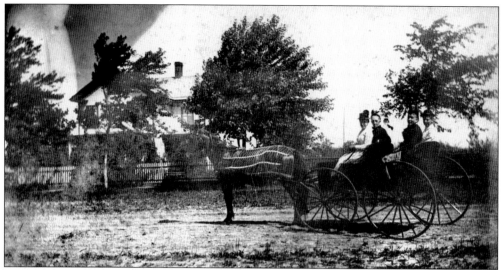

OUT FOR A RIDE, C. 1890. Four ladies, including Mrs. Theodore Pierson (1831–1903) and Fanny Ludlow Hardacre (1841–1933), are out for a ride on Montauk Highway. Their carriage is in front of the James Hedges house, which was later owned by the Hedges's daughter Nellie (1875–1981).

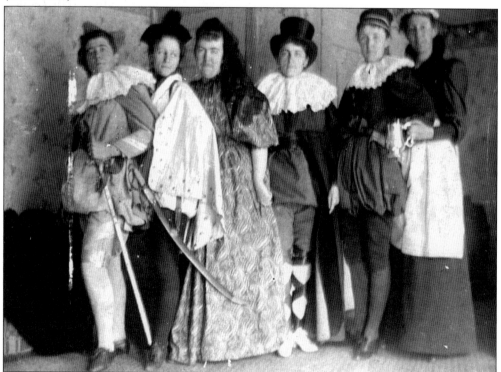

TWELFTH NIGHT, JANUARY 1894. At the William Corwith house on Main Street, in a room known as the Parlors, this group reenacts the Shakespearean play *Twelfth Night* in homemade costumes. From left to right are Jessie Topping, Katherine, Lil Hand, Lucy Howell, Lil Corwith, and Emily. Amateur theatricals were immensely popular during the Victorian era, and in Bridgehampton, performances alternated among different homes.

THE BRIDGEHAMPTON AND SAGAPONACK SMOKING CLUB, C. 1900.
The Bridgehampton and Sagaponack Smoking Club meets. From left to right are the following: (front row) the Sayre brothers; (back row) Frank Topping of Bridgehampton, Floyd Halsey, and Frank Topping of Sagaponack.

BOATING ON SAG POND, FEBRUARY 24, 1900. Dick Howell and William P. Topping are shown on the shore of Sag Pond. In the background is the Big Sag Pond Sandhill, a feature that was present for many years.

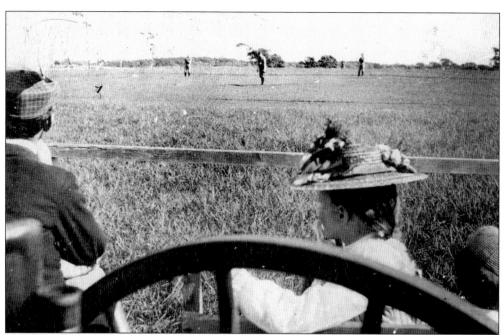

THE BASEBALL GROUNDS, C. 1900–1910. The original baseball grounds were located west of Lockwood Avenue, just beyond the present Bridgehampton School.

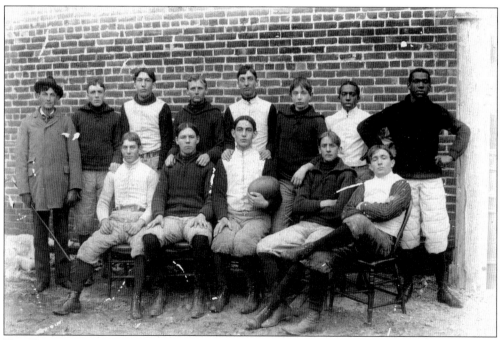

THE BRIDGEHAMPTON BOYS' FOOTBALL TEAM, C. 1900. From left to right are the following: (front row) S. Ralph Halsey, Fred Sandford, Elmer Smith, Sam Milford (?), and John King; (back row) Ned Pierson, Will J. Hedges, Frank Smith, Charles Hildreth, Malcolm Halsey, Harry Hildreth, Gus Marshall (?), and Al Marshall.

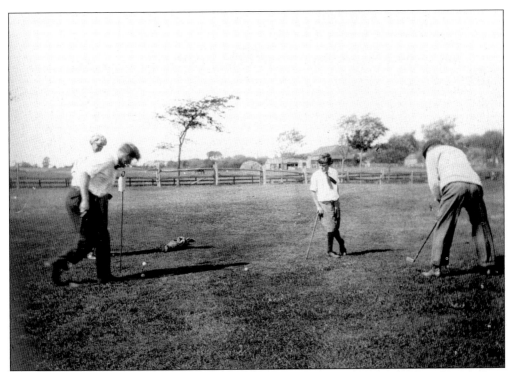

AT THE BRIDGEHAMPTON GOLF AND TENNIS CLUB, C. 1906. Golfers practicing their putting on the grounds of the golf club.

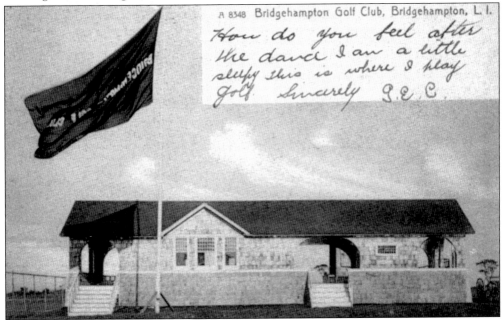

A 8348 Bridgehampton Golf Club, Bridgehampton, L. I.

How do you feel after the dance I am a little sleepy this is where I play golf Sincerely G. E. C.

THE BRIDGEHAMPTON CLUB, C. 1916. Formed originally as the Bridgehampton Golf and Tennis Club, the organization was united in the 1950s with the Bridgehampton Bathing Pavilion to become the present Bridgehampton Club. The original clubhouse still stands today, although its grand covered porches have for the most part been enclosed.

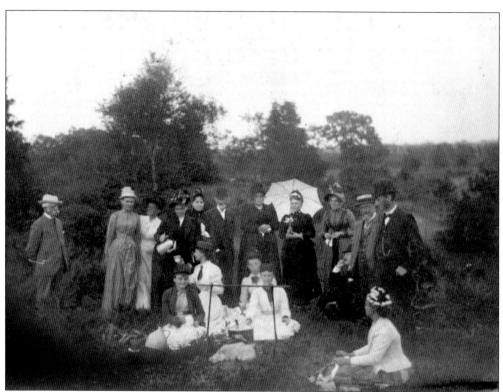

A PICNIC IN THE YARD AT LUDLOW GRANGE, C. 1907. A number of residents, probably including members of the Clowes, Ludlow, Pierson, and Esterbrook families, attend an informal picnic on the grounds of Ludlow Grange. The woman holding the umbrella is Fanny Ludlow Hardacre (1841–1933).

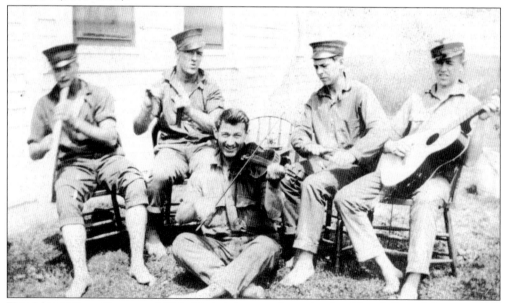

THE MECOX JAZZ BAND, C. 1915. Little is known about this local band. From left to right are "Rev." Dull, Roland, Floyd and Bill Sullivan, and Frank Johnson.

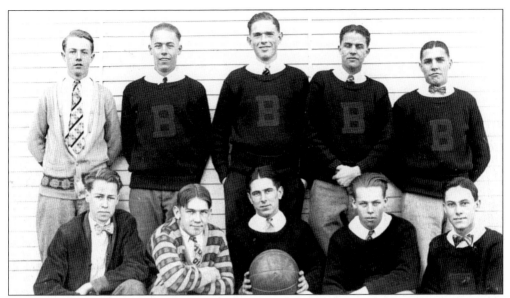

THE BRIDGEHAMPTON HIGH SCHOOL BOYS' BASKETBALL TEAM, 1927–1928. From left to right are the following: (front row) Edwin Hendrickson, Everett Winkler, Roger Maran, Irwin Hedges, and A. Prescott Halsey; (back row) Charles Havens, Allen Hedges, Larry Hildreth, Howard Vail, and Ivan Topping. Bridgehampton has been known for its top-quality basketball teams since the early part of the 20th century. Today's successful boys' team is known as the "Killer Bees."

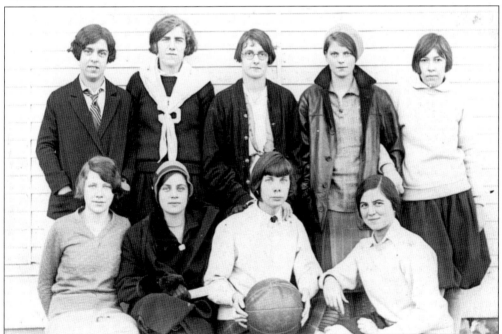

THE BRIDGEHAMPTON HIGH SCHOOL GIRLS' BASKETBALL TEAM, 1927–1928. From left to right are the following: (front row) Mary Tiffany, Ethel Diffene, Marguerite Deckert, and Minetta Pierson; (back row) Harriet Voorhees, Ella Mae Squires, Elizabeth Hildreth, Lois Acker, and Violette Downs.

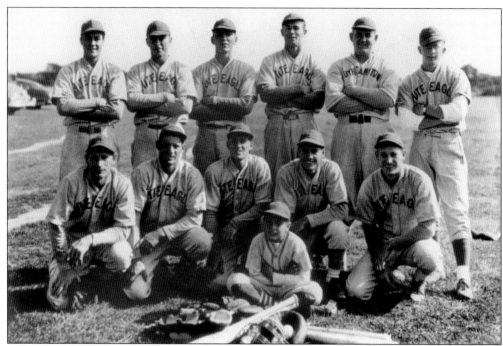

THE WHITE EAGLES BASEBALL TEAM, C. 1947. Bridgehampton participated regularly with the other early Long Island regional baseball competitions. The White Eagles team was one of the best ones put together from Bridgehampton and was the starting ground for one of the more famous players of the 20th century, Carl Yastrzemski (b. 1939), shown as a young bat boy (front center).

THE HAMPTON CLASSIC GROUNDS. One of the premiere horse shows in America today, the Hampton Classic grew out of the old Southampton Horse Show, which was held from the 1920s through 1964 and again from 1971 through 1976. In 1976, the Southampton Horse Show and the Sagaponack Horse Show combined to create the first Hampton Classic, which was held in East Hampton. In 1982, the Hampton Classic grounds moved to a 60-acre lot on Snake Hollow Road in Bridgehampton, where it has been ever since. Each year competitors from around the world arrive for the multi-day event to compete for the $100,000 grand prize.

Ten
THE RACES

Along with Watkins Glen in upstate New York, Bridgehampton is one of the earliest sites in American for the sport of road racing. It is an "itch" that Bridgehampton could not get rid of, even after crashes in both the first (1915–1920) and second (1949–1953) series of races occurred. The Bridgehampton Track removed racing from the streets permanently, bringing a whole new type and style to the history of racing in Bridgehampton. Literally, the best racers in the world came to Bridgehampton to show off their stuff. There was no place like it anywhere else in America, and there still is not. Although it appears that the sun has set on the future of racing in the hamlet, at least for now, it does not hurt to look back at just a little of what made racing in Bridgehampton so great.

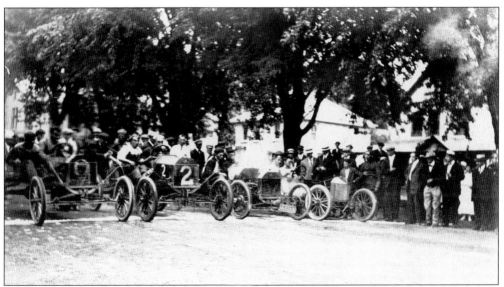

THE BRIDGEHAMPTON ROAD RACES, C. 1915. Racers line up on Main Street in front of the house owned by J.A. Sandford & Son. The races began as part of the Fireman's Carnival, and the first occurred on July 24, 1915. In addition to automobiles, early motorcycles took part in the races.

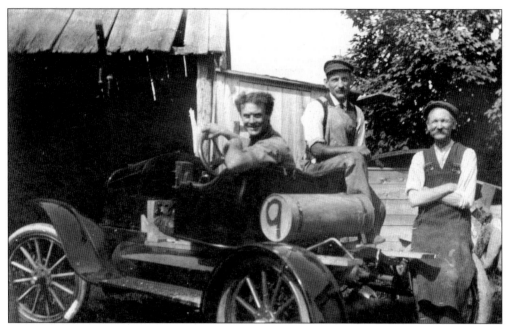

READYING FOR THE RACE, 1915. Herb Cooper visits with local car repairmen Howard Halsey and Francis McCaslin before the 1915 race. He is seated in car No. 9, a Model T Ford.

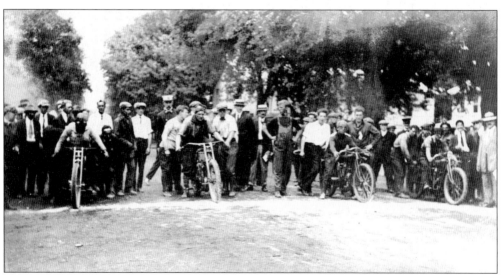

READY TO TAKE OFF, 1915. Early motorcycles line up on Main Street as they prepare to begin their portion of the race.

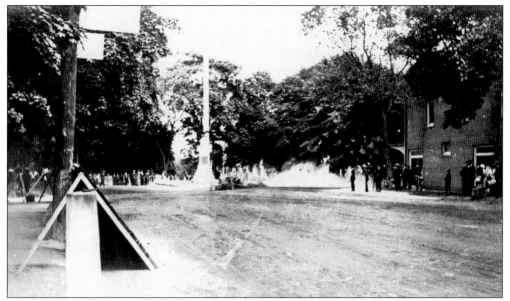

A Car Rounds the Bend, c. 1915. An automobile is shown as it attempts (not too successfully) to come around monument corner and onto Main Street. It just misses the monument embankment, sending a cloud of dust up behind it. The protective wooden A-frame wall (left foreground) was erected to protect spectators. The building is the D.L. Chester Store (right).

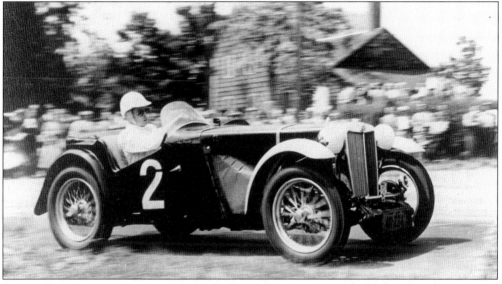

Bruce Stevenson at the 1949 Race. Bruce Stevenson rounds the bend at the corner of Bridge Lane and Ocean Road in the no. 2 car, an MG. On June 11, 1949, the first race to occur in 29 years was held in Bridgehampton. Stevenson was one of the creators of the second group of races that were sponsored by the Lions Club, the MG Car Club, the Sports Car Club of America, and the Motor Sports Club of America. Participants in small cars traveled 12 laps (48 miles)—later changed to 18 laps (72 miles)—while the larger vehicles traveled 25 laps (100 miles). The route went from Ocean Road to Sagaponack Road, Sagg Main Street, Bridge Lane, and finally back to Ocean Road.

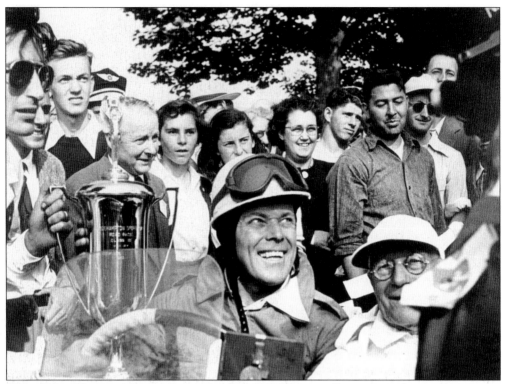

THE 1949 WINNER. Bruce Stevenson (far left foreground) presents the trophy cup to champion George Huntoon (center), who won the 1949 race in the 1936 Alfa Romeo owned by Sam Bird (right foreground). Huntoon traveled at an average speed of 76.17 miles per hour.

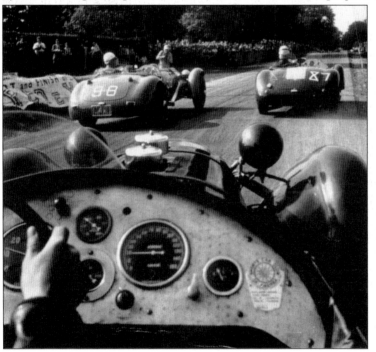

FROM THE DRIVER'S SEAT, C. 1950. This is one of four photographs taken from the driver's seat in Bruce Stevenson's Meyer Special at the 1950 Bridgehampton Races. That year, Britain's own Tommy Cole won the race in a Chrysler-Allard that traveled the course at the average speed of 79 miles per hour.

THE RACETRACK, 1957. Following an accident at the 1953 race, racing on the streets of Bridgehampton came to an end but not racing itself. An effort was led to create a racing circuit at Bridgehampton that would be unlike any other in the world. The 2.85 mile, 13-turn track was completed and opened for it debut race on September 29, 1957. The track held many events, including those sponsored by the Sports Car Club of America. Over time, growing opposition to the course, mainly by homeowners who lived around the track, led to noise ordinances that all but halted most racing. The track held its last events in the mid-1990s and is currently being redeveloped as a private golf course.

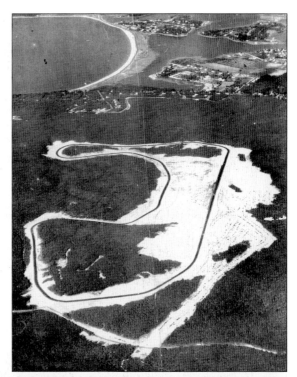

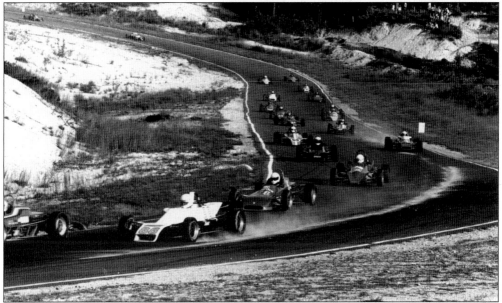

A FORMULA RACE AT THE TRACK, C. 1970. A course that challenged even the experts, Bridgehampton's track hosted many famous drivers, including Mario Andretti, Jack Brabham, Dan Gurney, Jim Hall, Walt Hansgen, Denny Hulme, Bruce McLaren, Peter Revson, Pedro Rodriguez, Jo Siffert, and John Surtees. According to one noted racing instructor, "All who have raced there know that the earth is flat and ends in the sand at turn two. The emotional rewards of driving this turn 'flat out' are just as intense as the physical consequences of blowing it."

BIBLIOGRAPHY

Adams, James Truslow. *Memorials of Old Bridgehampton*. Port Washington, New York: Ira J. Friedman, 1962.

Banta, Theodore. *Sayre Family: Lineage of Thomas Sayre, A Founder of Southampton*. Massachusetts: The Higginson Book Company, 2000 (reprint).

Belcher-Hyde, E. *Atlas of a Part of Suffolk County, Long Island, New York, South Side–Ocean Shore*. New York: E. Belcher–Hyde, c. 1902.

———. *Atlas of a Part of Suffolk County, Long Island, New York, South Side–Ocean Shore*. 2 vols. New York: E. Belcher-Hyde, 1916.

Bicentennial of the Presbyterian Church in Bridge-Hampton November 10th, 1886. Sag Harbor, New York: Express-Stream Print, 1886.

Bridge Hampton Historical Society. *Bridge Hampton Works and Days*. New York: Vintage Books, 1975.

———. Clipping File, A-O. Held by Bridge Hampton Historical Society, Bridgehampton, New York.

———. Corwith Family Letter Collection, c. 1830s–1880 (unpublished). Held by Bridge Hampton, Historical Society, Bridgehampton, New York.

———. Corwith Family Receipt Collection, c. 1780s–1910 (unpublished). Held by Bridge Hampton Historical Society, Bridgehampton, New York.

———. Edgewood Cemetery File. Held by Bridge Hampton Historical Society, Bridgehampton, New York.

———. Local Cemetery Files. Held by Bridge Hampton Historical Society, Bridgehampton, New York.

———. Obituaries File. Copy held by Bridge Hampton Historical Society, Bridgehampton, New York.

———. Records of the Bridgehampton Methodist Church, 1836-1960. Held by Bridge Hampton Historical Society, Bridgehampton, New York.

Carpenter, Bryant. *The Classic Experience: The Hampton Classic*. Bridgehampton, New York: Carl Miller American Yearbook Sales, 1995.

Clowes, Ernest S. *Wayfarings, A Collection Chosen from Pieces which Appeared under that Title in the Bridgehampton News 1941–1953*. Bridgehampton, New York: 1953.

Corwith, David. Last Will and Testament, 1798 (handwritten notes in Corwith Genealogy File). Held by Bridge Hampton Historical Society, Bridgehampton, New York.

Corwith, F.E. Corwith Genealogy, March 1916 (unpublished). Copy held by Bridge Hampton Historical Society, Bridgehampton, New York.

Corwith, Henry. Last Will and Testament, 1820. Copy held by Bridge Hampton Historical Society, Bridgehampton, New York.

Curts, Paul H., ed. *Bridgehampton's Three Hundred Years*. Bridgehampton, New York: The Hampton Press, 1956.

Faris, David. *The Descendants of Edward Howell*. Baltimore, Maryland: Gateway Press, 1985.

Foner, Eric and John A. Garraty. *The Reader's Companion to American History*. Boston: Houghton Mifflin Co., 1991.

Halsey, William D. *Sketches From Local History*. Southampton, New York: Yankee Peddler Book Company, 1966.

Hamill, Corwith. *The Corwiths Of Galena*. 2000 (unpublished). Copy held by Bridge Hampton Historical Society, Bridgehampton, New York,

Heartt, John E., ed. *Story of A Celebration*. Sag Harbor, New York: John H. Hunt, 1910.

Hendrickson, Richard. *Winds of the Fishes Tail*. Mattituck, New York: Amereon Press, 1996.

Howell, George Rogers. *History of Southampton, Long Island, New York*. Albany, New York: Weed, Parsons, and Company, 1887.

Johnson, William Lee, ed. *A Genealogical Study of the Family of Charles Evans Hughes (1862–1948)*. Washington, DC: The Supreme Court Historical Society, 1994.

Long Island Railroad Company. *Long Island and Where to Go!* New York: Lovibond and Jackson, 1877.

Manual of the Presbyterian Church, in Bridge-Hampton, Suffolk County, N.Y. Sag Harbor, New York: John H. Hunt, 1874.

Mather, Frederic G. *The Refugees of 1776 from Long Island to Connecticut*. Albany, New York: J. B. Lyon and Company, 1916.

New York Times, the 1851–present.

Pelletreau, William S., H.D. Sleight, et al. *Records of the Town of Southampton*. Volumes 1–7. Sag Harbor, New York: John H. Hunt, 1874–1928.

Presbyterian Church of Bridgehampton. *Three Hundred Years of Faith, 1670–1970*. Bridgehampton, New York: 1970.

Queen of the Most Holy Rosary Parish, Bridgehampton, New York. *Queen of the Most Holy Rosary R.C. Church. Golden Jubilee, 1922–1972*. Bridgehampton, New York: The Hampton Press, 1972.

Rattray, Jeannette. *East Hampton History, Including Genealogies of Early Families*. Garden City: Country Life Press, 1953.

Records of the Town of East Hampton, Long Island, New York. Vol. 4. Sag Harbor, New York: John H. Hunt, 1889.

Tolleson, Katrin. "When Half a House Is Better," *House Beautiful*, Vol. 127, No. 8, August 1985, pages 60–67.

Town of Southampton. Sagaponack National Register Nomination (draft) Southampton, New York: Town of Southampton, 2000.

Zaykowski, Dorothy. *Sag Harbor: An American Beauty*. Mattituck, New York: Amereon Press, 1991.